Fra Angelico:
121 Paintings and Drawings

By Maria Tsaneva

First Edition

Fra Angelico: 121 Paintings and Drawings

Copyright © 2015 by Maria Tsaneva

Foreword

Fra Angelico was Florentine painter and Dominican friar originally named Guido di Pietro. Although in popular tradition he has been seen as "not an artist properly so-called but an inspired saint", (Ruskin), Angelico was in fact a highly professional artist, who was in touch with the most advanced developments in contemporary Florentine art and in later life traveled extensively for prestigious commissions.

Angelico entered a Dominican convent in Fiesole in 1418 and became a friar using the name Giovanni da Fiesole. Although his teacher is unknown, he apparently began his career as an illuminator of missals and other religious books. He began to paint altarpieces and other panels; among his important early works are the Madonna of the Star (c. 1424, San Marco, Florence) and San Domenico Altarpiece with a predella representing Christ in Glory Surrounded by Saints and Angels, which depicts more than 250 distinct figures. Among other works of that period are two of the Coronation of the Virgin and The Deposition and The Last Judgment (San Marco). His mature style is first seen in the Madonna of the Linen Weavers (1433, San Marco), which features a border with 12 music-making angels.

In 1436 some of the Dominican friars of Fiesole moved to the convent of San Marco in Florence, which had recently been rebuilt by Michelozzo. Angelico, sometimes aided by assistants, painted many frescoes for the cloister, chapter house, and entrances to the 20 cells on the upper corridors. The most impressive of these are The Crucifixion, Noli Me Tangere, and Transfiguration. His altarpiece for San Marco (1439) is one of the first representations of what is known as a Sacred Conversation: the Madonna flanked by angels and saints who seem to share a common space. In 1445 Angelico was summoned to Rome by Pope Eugenius IV to paint frescoes for the now destroyed Chapel of the Sacrament in the Vatican. In 1447, with his pupil Benozzo Gozzoli, he painted frescoes for the cathedral in Orvieto. His last important works, frescoes for the chapel of Pope Nicholas in the Vatican, are Scenes from the Lives of Saints Stephen and Lawrence (1447-1449), probably partly painted from his designs by assistants.

Angelico died in Rome and was buried in the church of S. Maria sopra Minerva, where his tombstone still exists. His most important pupil was Benozzo Gozzoli and he had considerable influence on Italian painting. He painted numerous altarpieces as well as frescos, several outstanding examples being in the S. Marco museum. His particular grace and charm stimulated the school of Perugia, and Fra Bartolommeo, who followed him into S. Marco in 1500, had something of his restraint and grandeur. Vasari, who referred to Fra Giovanni as a simple and most holy man, popularized the use of the name Angelico for him, but he says it is the name by which he was always known, and it was certainly used as early as 1469. The painter has long been called 'Beato Angelico' (the Blessed Angelico), but his beatification was not made official by the Vatican until 1984.

Angelico combined the influence of the elegantly decorative International Gothic style of Gentile da Fabriano with the more realistic style of such Renaissance masters as the painter Masaccio and the sculptors Donatello and Ghiberti, all of whom worked in Florence. Angelico was also aware of the theories of perspective proposed by Leon Battista Alberti. Angelico's representation of devout facial expressions and his use of colour to heighten emotion are particularly effective. His skill in creating monumental figures, representing motion, and suggesting deep space through the use of linear perspective, especially in the Roman frescoes, mark him as one of the foremost painters of the Renaissance.

Paintings, Frescoes and Drawings

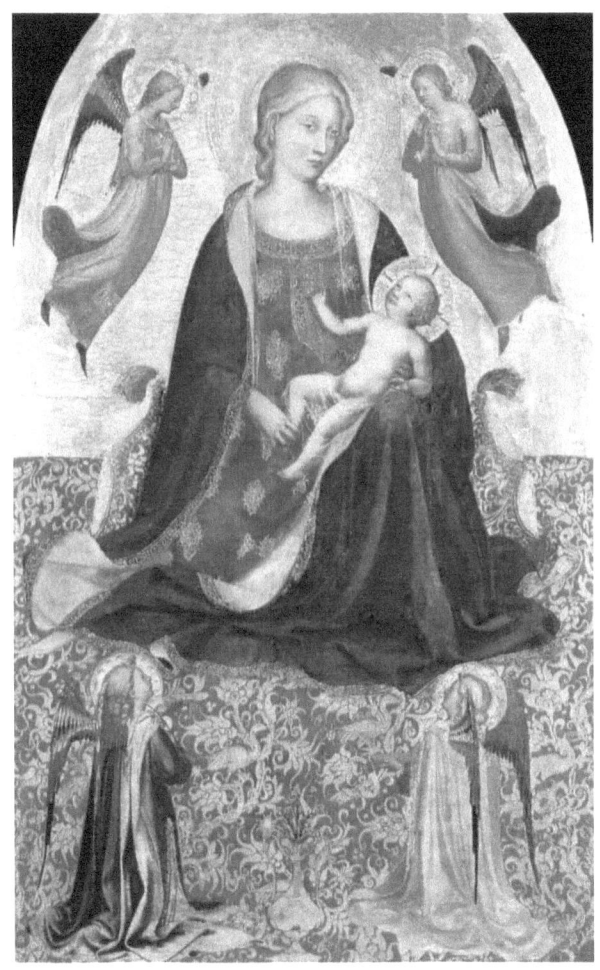

Madonna of Humility, c.1418
Tempera on panel

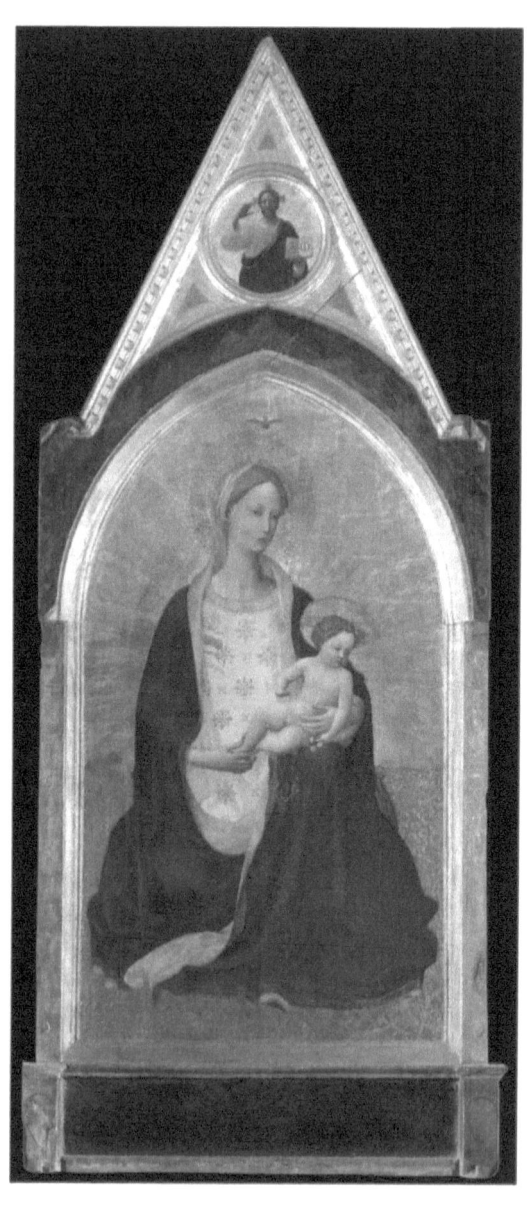

Madonna of Humility, c.1419
Tempera on panel

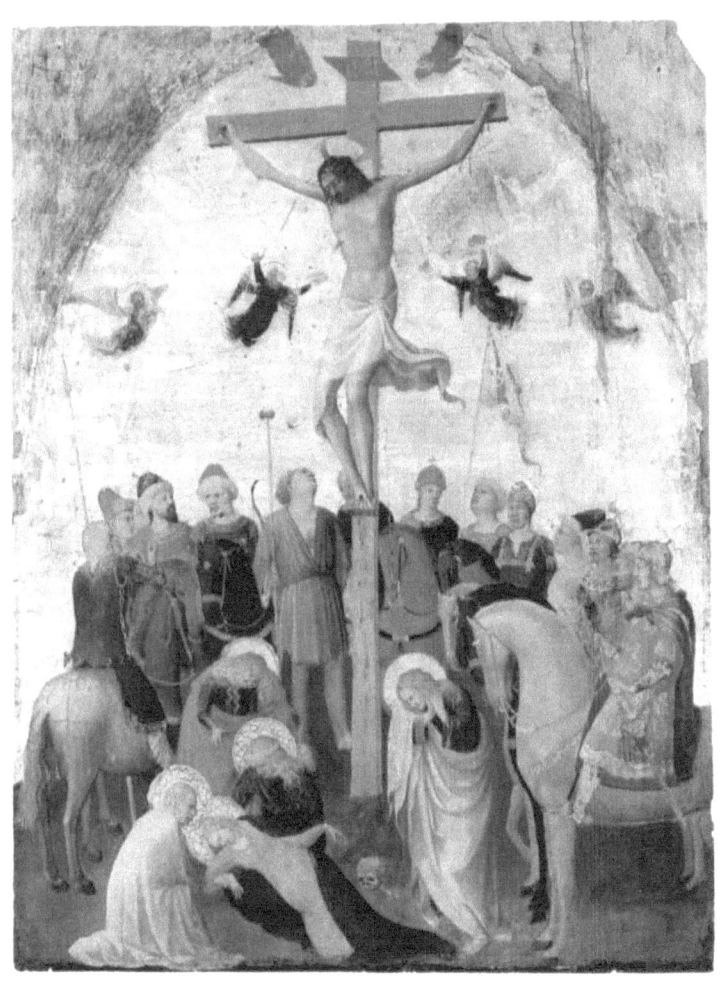

Crucifixion, c.1420
Tempera on panel

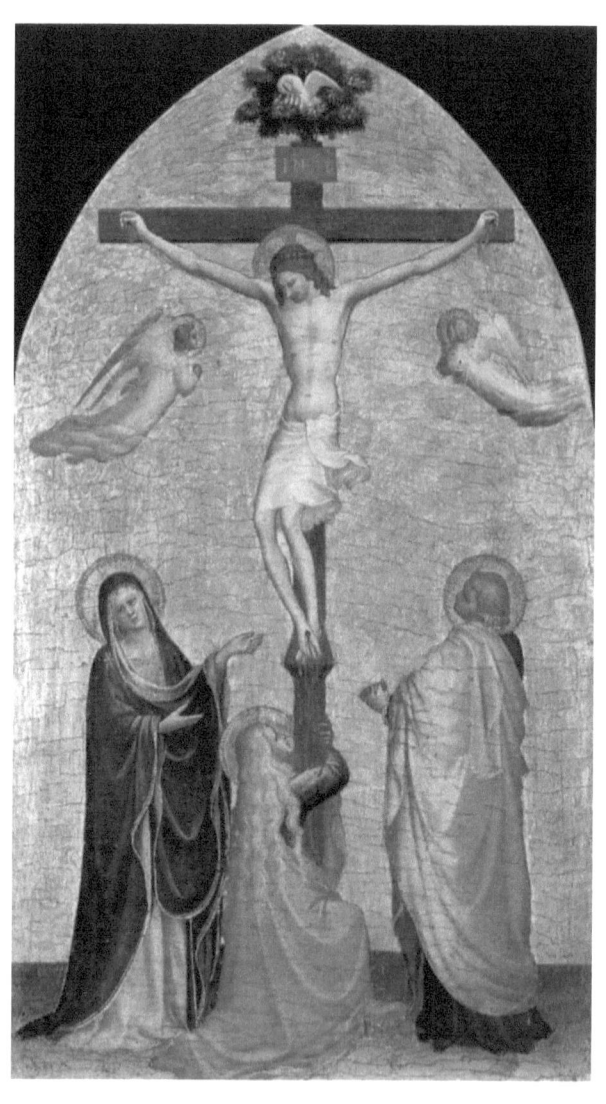

Crucifixion with the Virgin, John the Evangelist, and
Mary Magdelene, 1419-1420
Tempera on panel

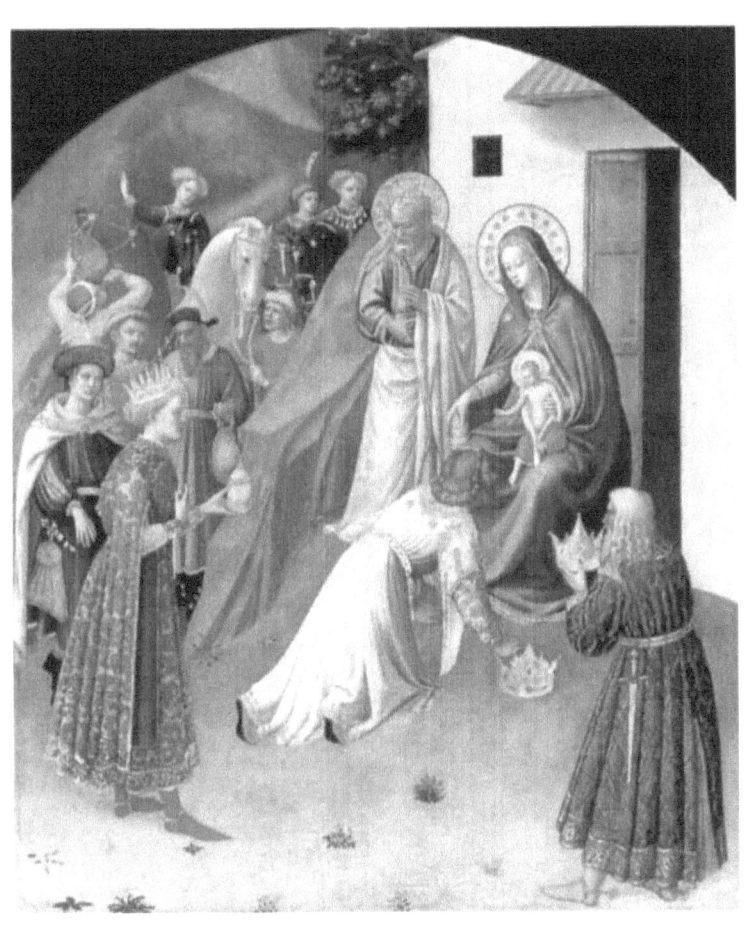

Adoration of the Magi, 1423-1424
Tempera on panel

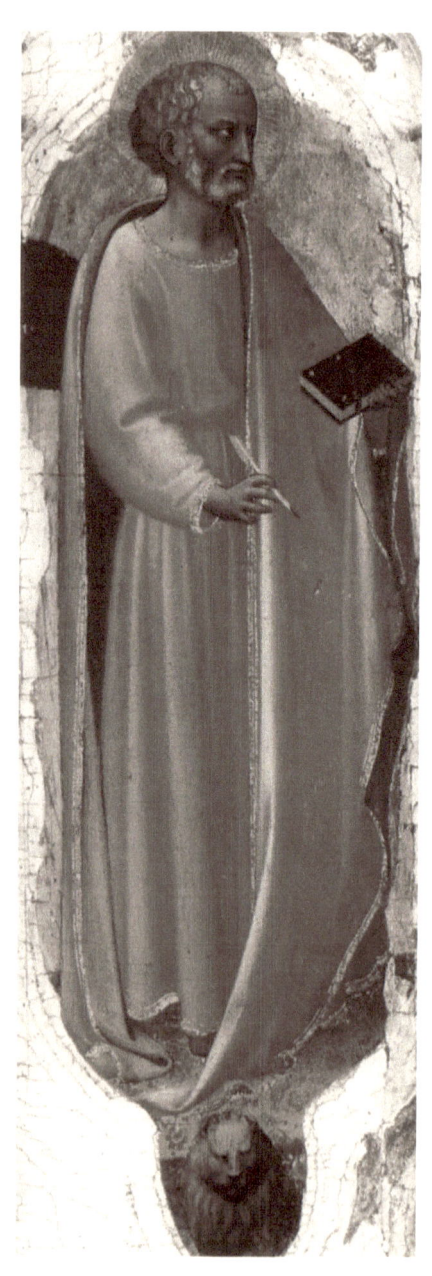

St. Mark, 1423-1424
Tempera on panel

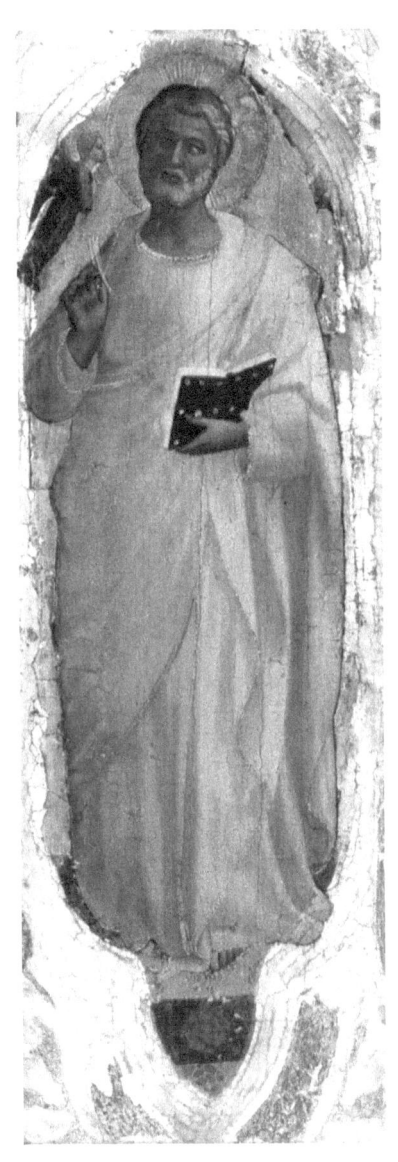

St. Matthew, 1423-1424
Tempera on panel

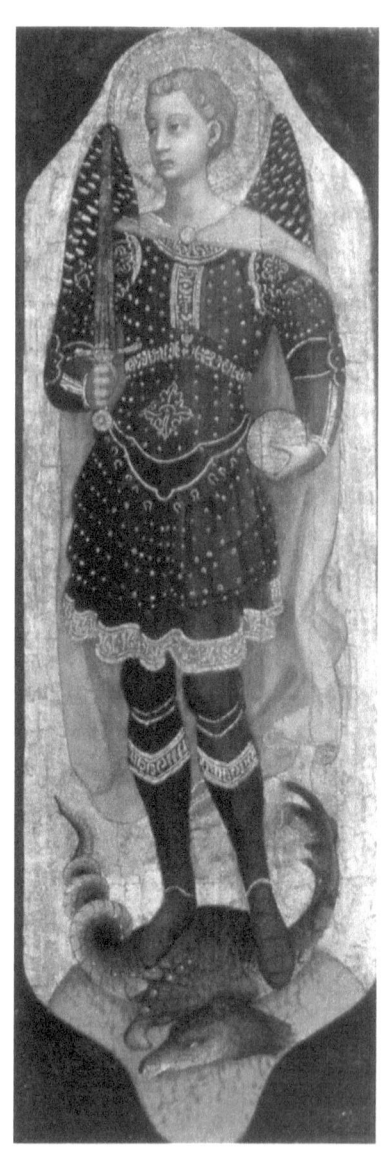

St. Michael, 1423-1424
Tempera on panel

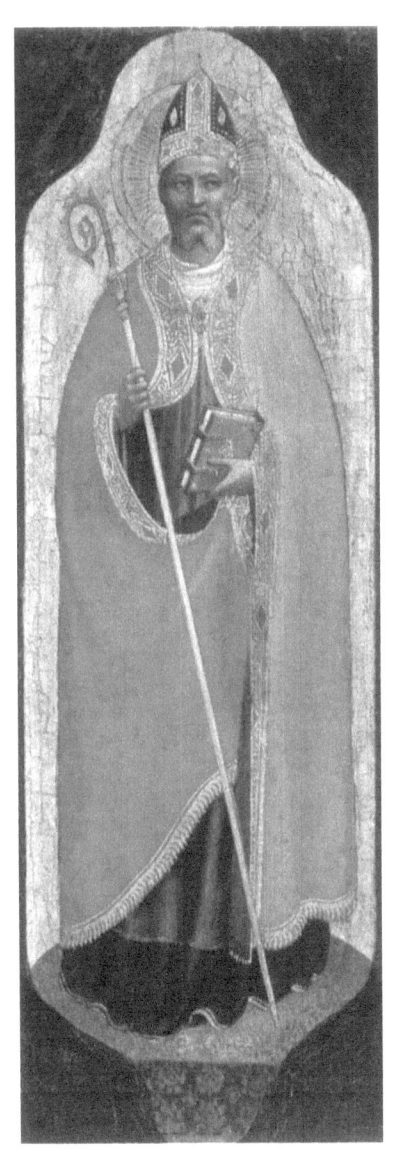

St. Nicholas of Bari, 1423-1424
Tempera on panel

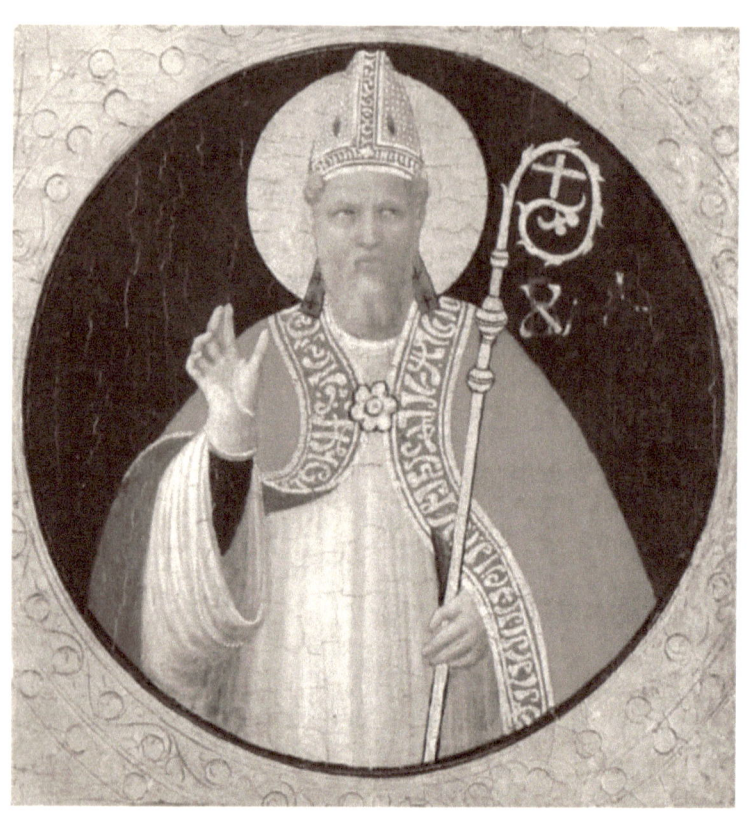

A Bishop Saint, c.1425
Tempera on panel

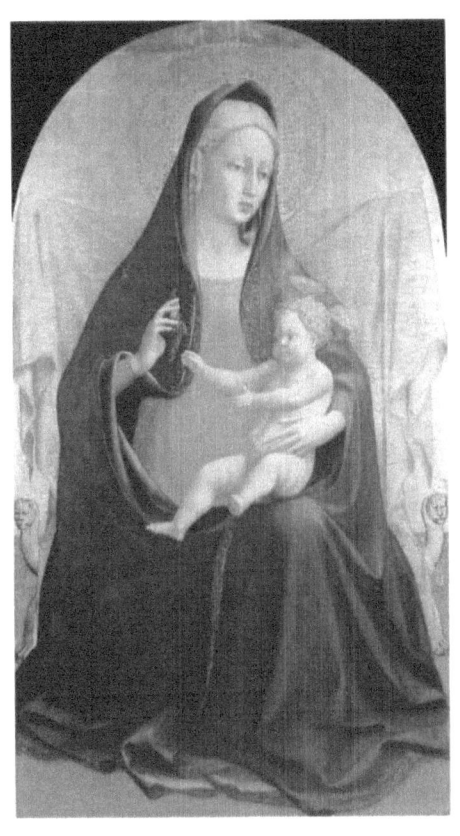

Madonna and Child of the Grapes, c.1425
Tempera on panel

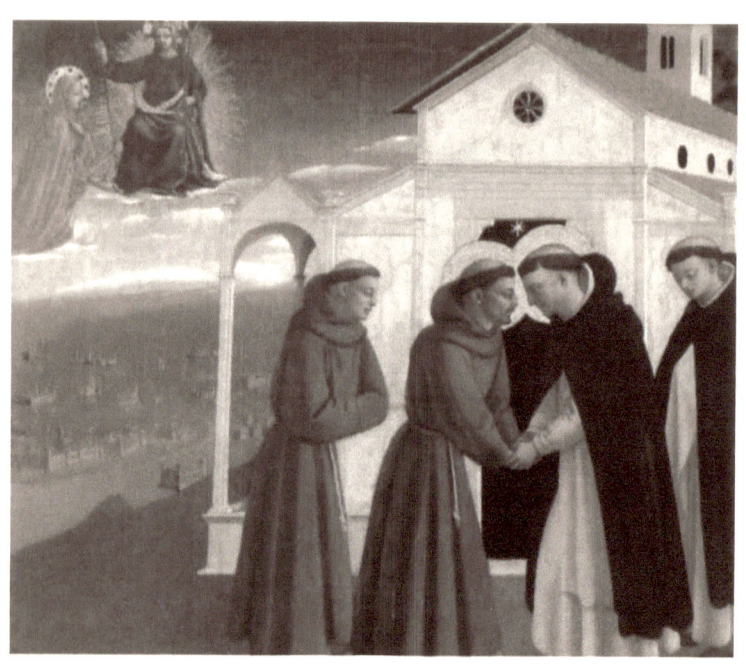

Meeting of St. Francis and St. Dominic, c.1429
Tempera on panel

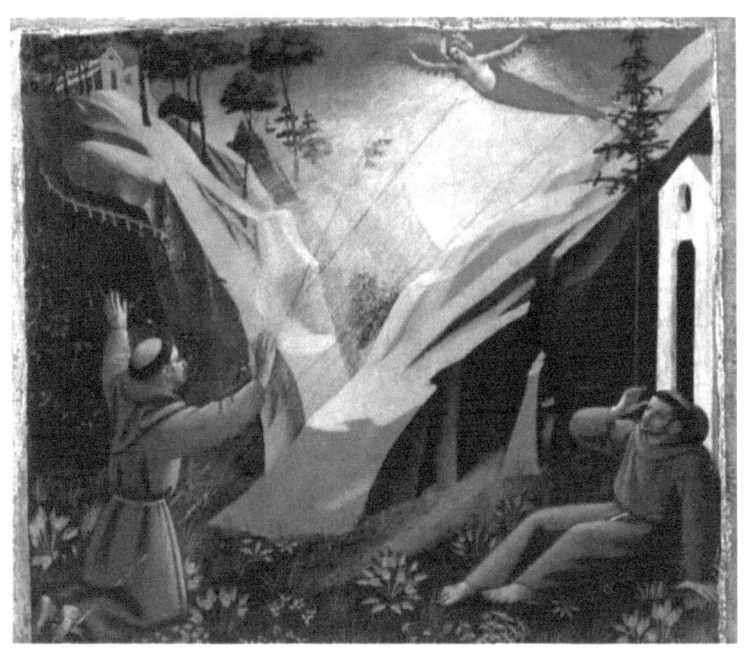

Receiving the Stigmata, c.1429
Tempera on panel

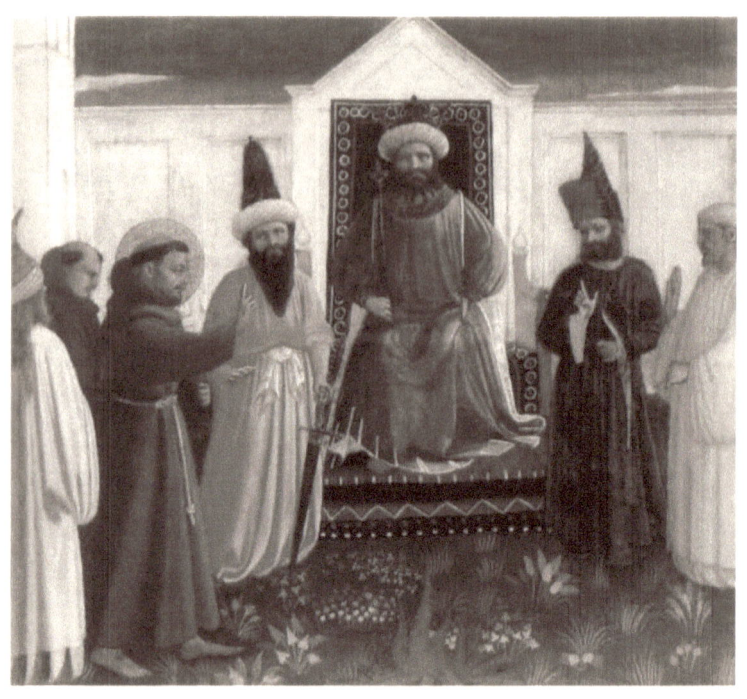

The Trial by Fire of St. Francis before the Sultan, c.1429
Tempera on panel

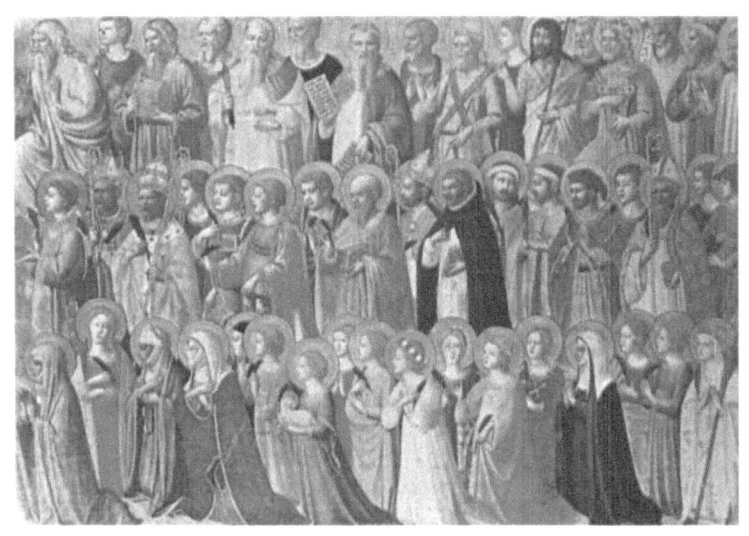

Christ Glorified in the Court of Heaven, 1428-1430
Tempera on panel

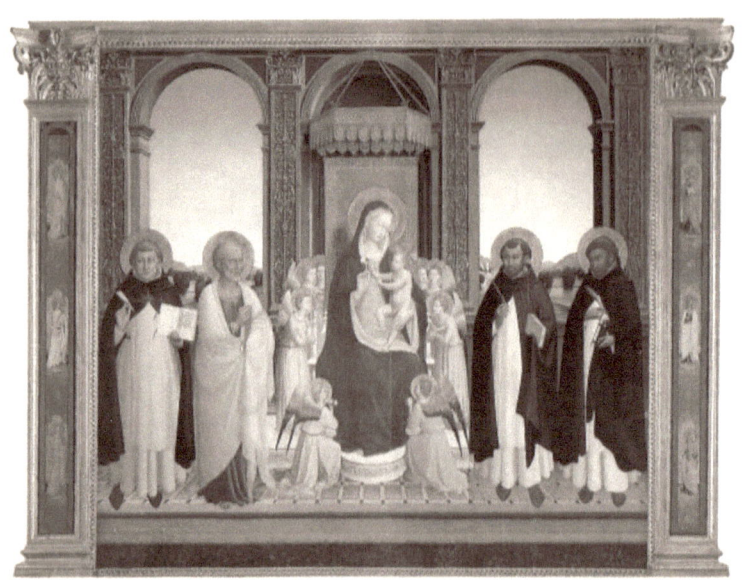

San Domenico Altarpiece, 1424-1430
Tempera on panel

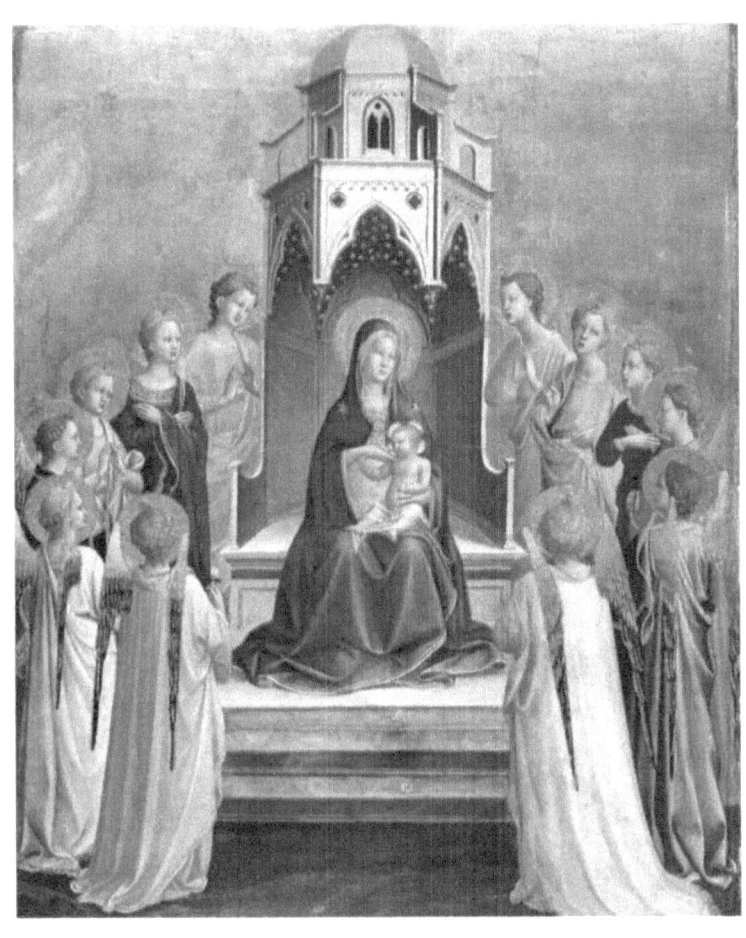

Virgin and Child Enthroned with Twelve Angels,
c.1430, Tempera on panel

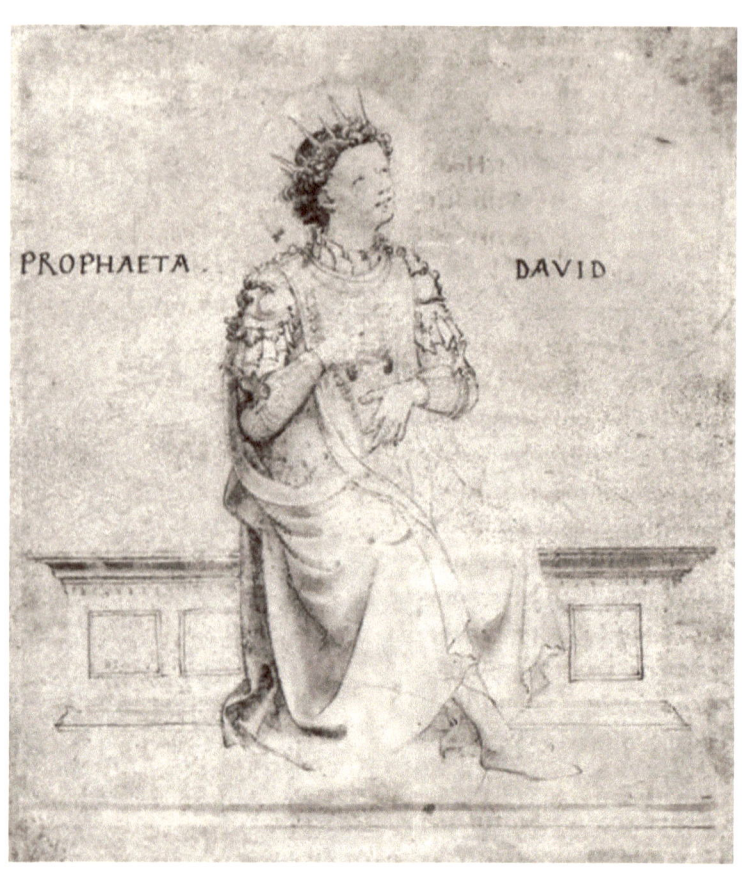

King David Playin a Psaltery, c. 1430
Pen and brown ink and purple wash on vellum, 197 x 179 mm

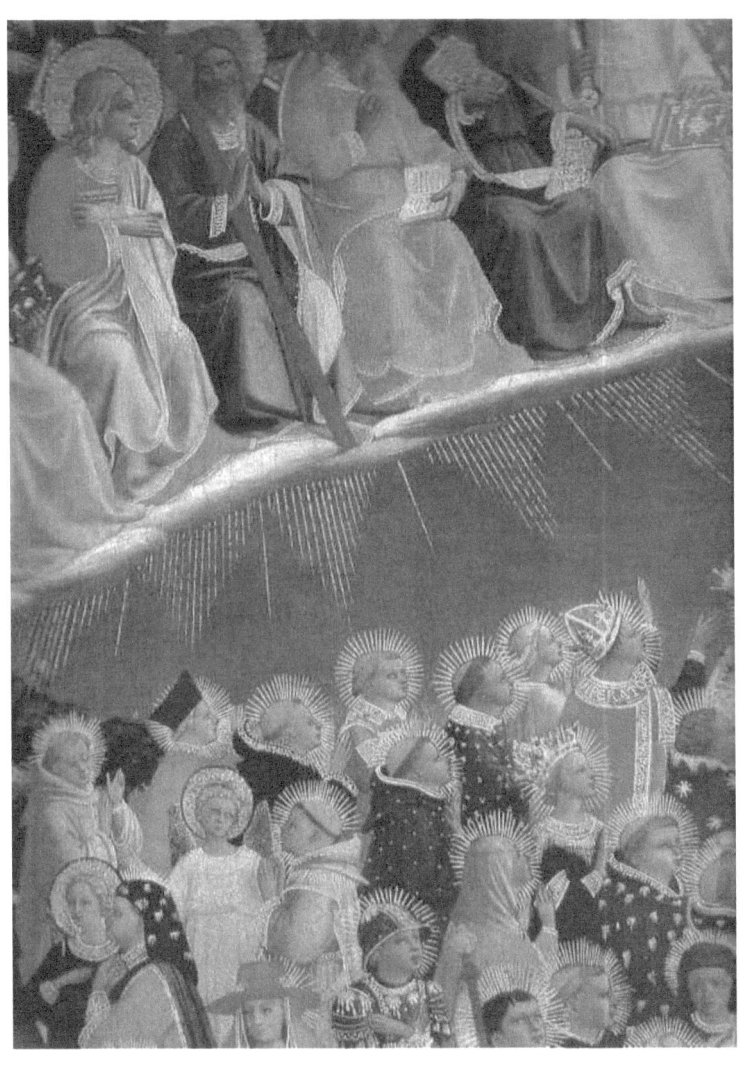

The Last Judgement, Detail: The Blessed, c.1431
Tempera on wood

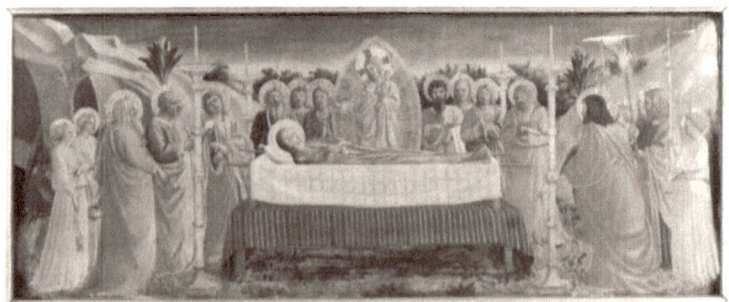

Annunciation, 1430-1432
Tempera on panel

Dormition of the Virgin, 1431-1432
Tempera on panel

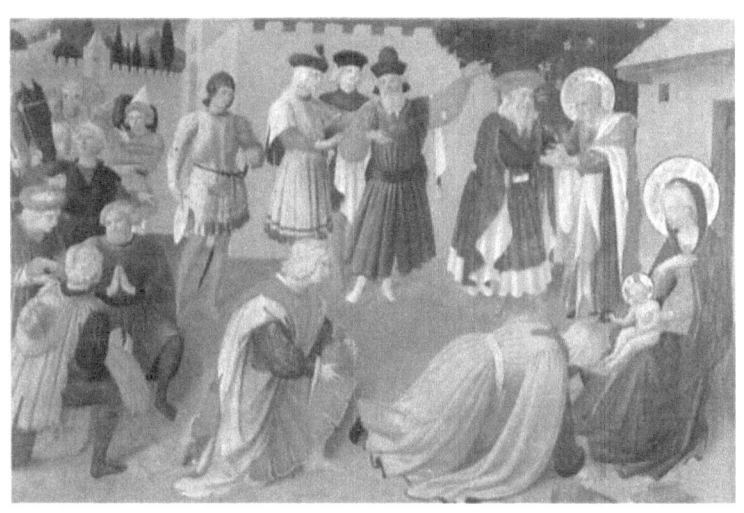

Adoration of the Magi, c.1433
Tempera on panel

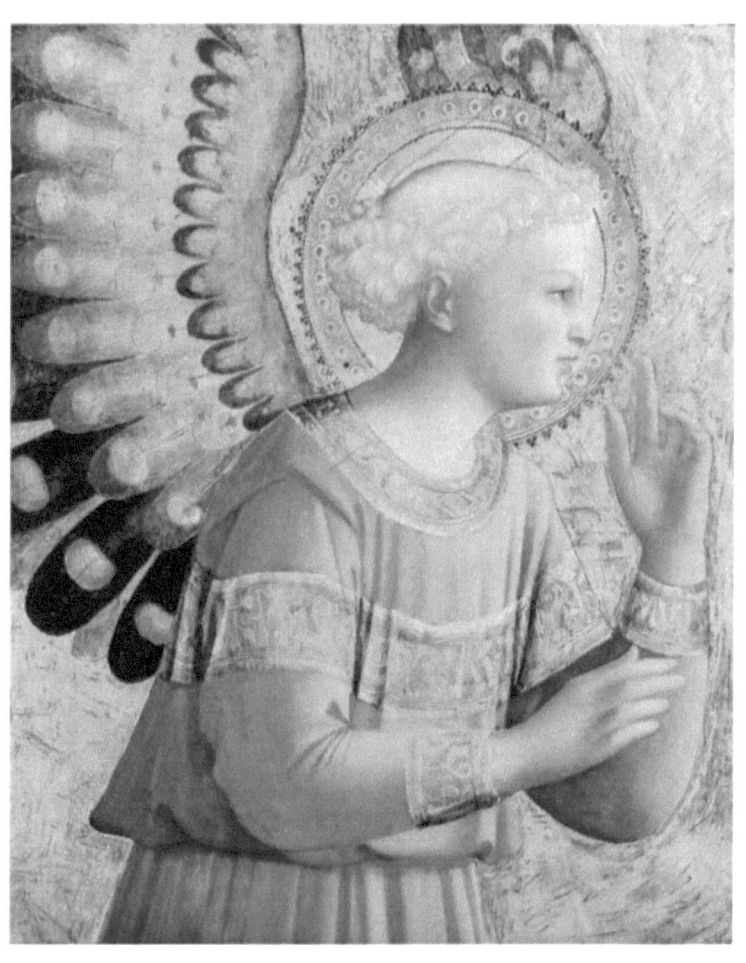

Archangel Gabriel Annunciate, 1431-1433
Tempera on paper

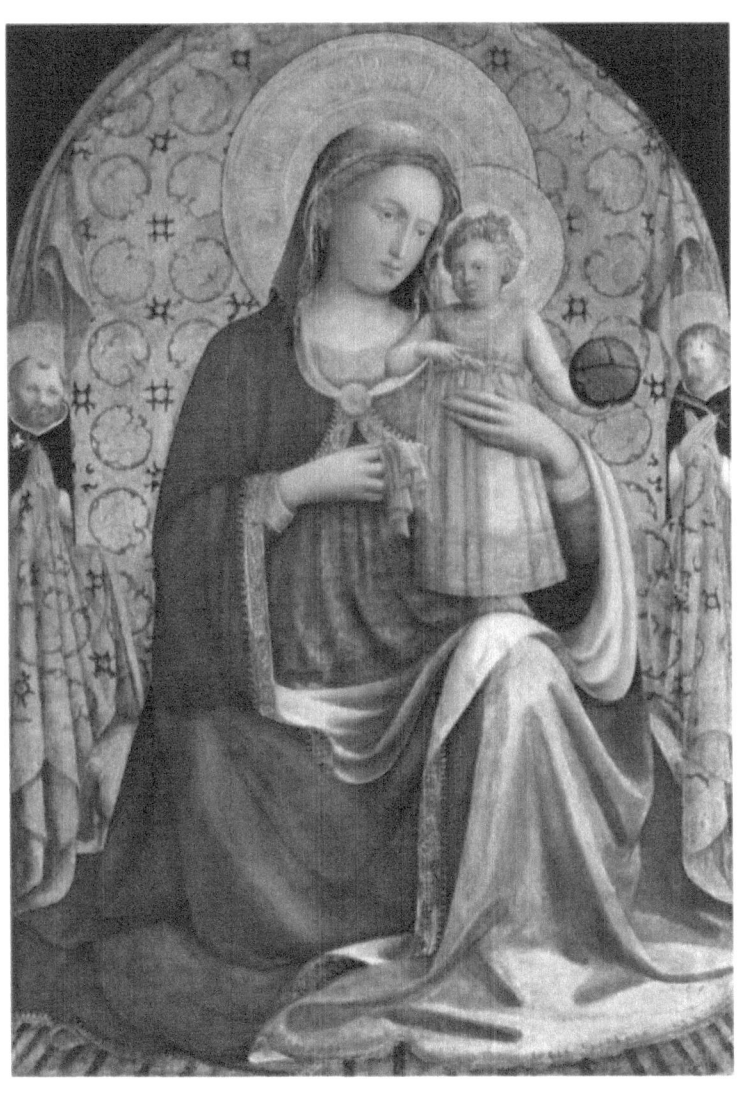

Madonna and Child, c.1433
Tempera on panel

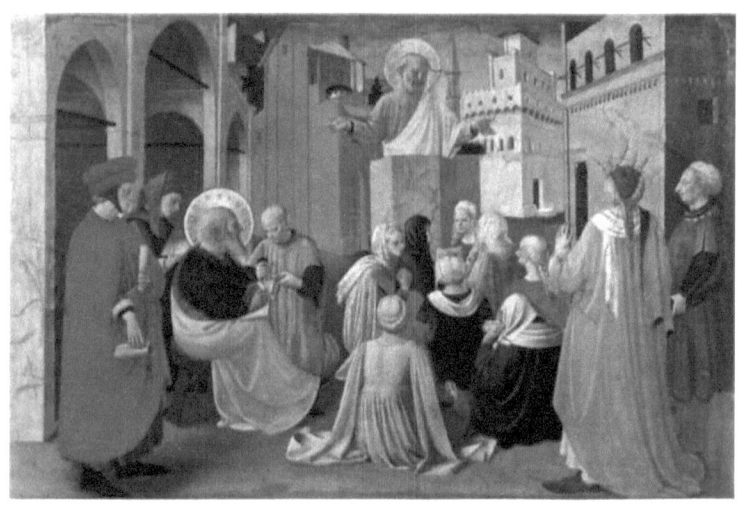

St. Peter Preaching in the Presence of St. Mark, c.1433
Tempera on panel

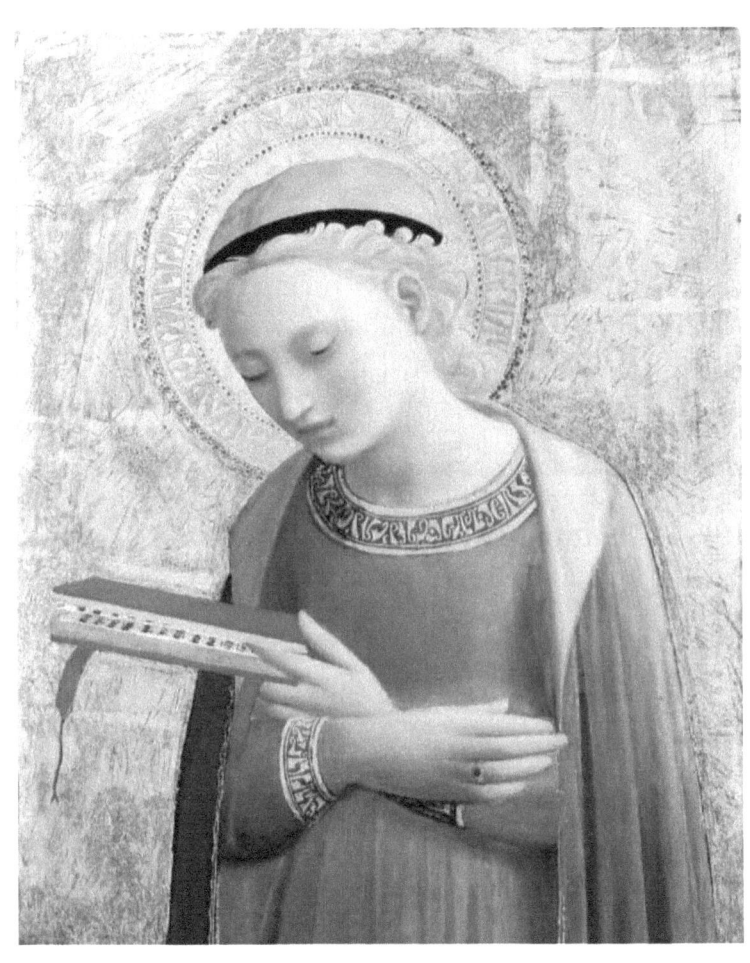

Virgin Mary Annunciate, 1431-1433
Tempera on panel

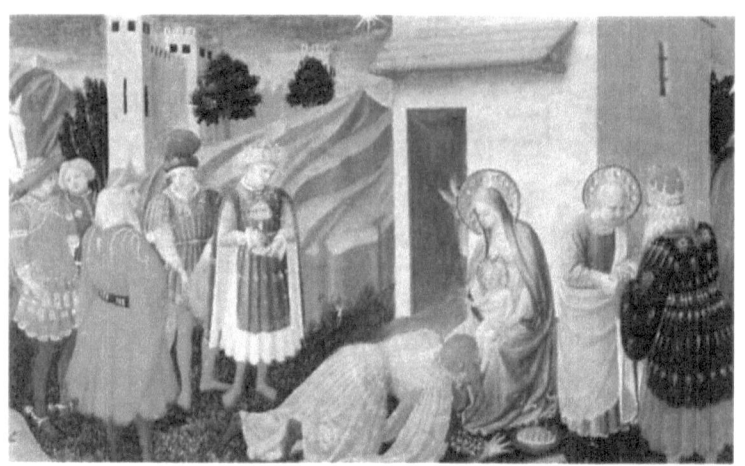

Adoration of the Magi, 1433-1434
Tempera on panel

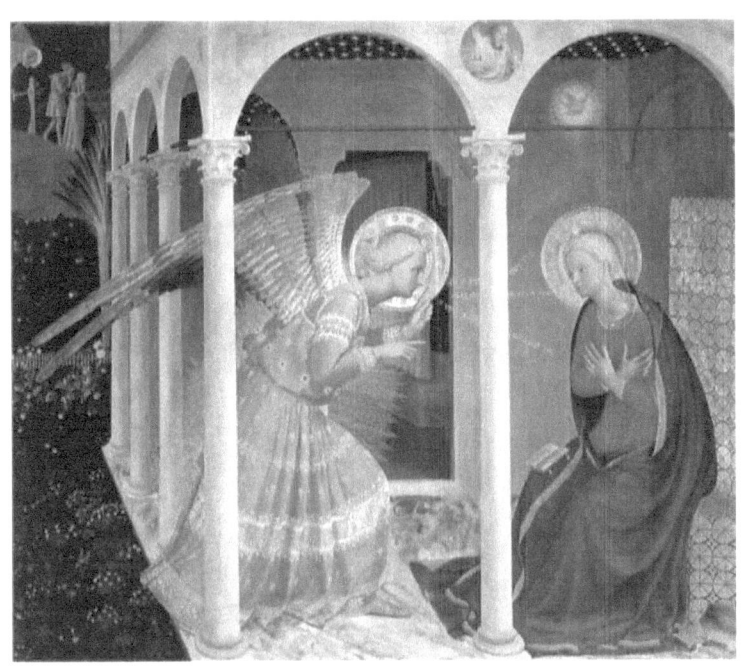

Annunciation, 1433-1434
Tempera on panel

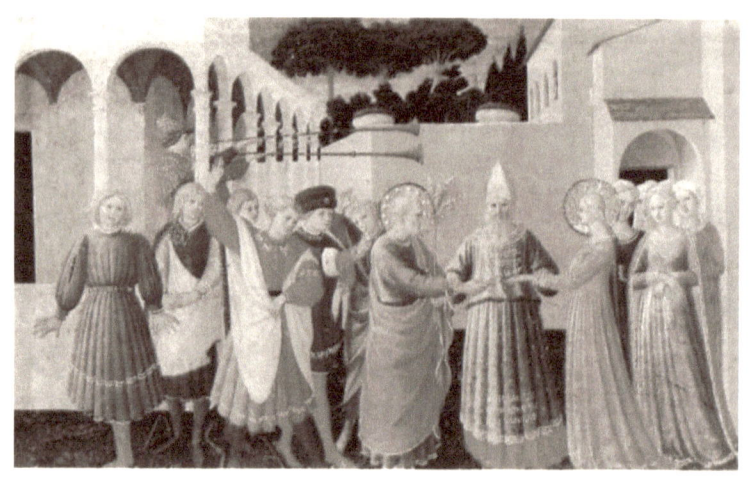

Marriage of the Virgin, 1433-1434
Tempera on panel

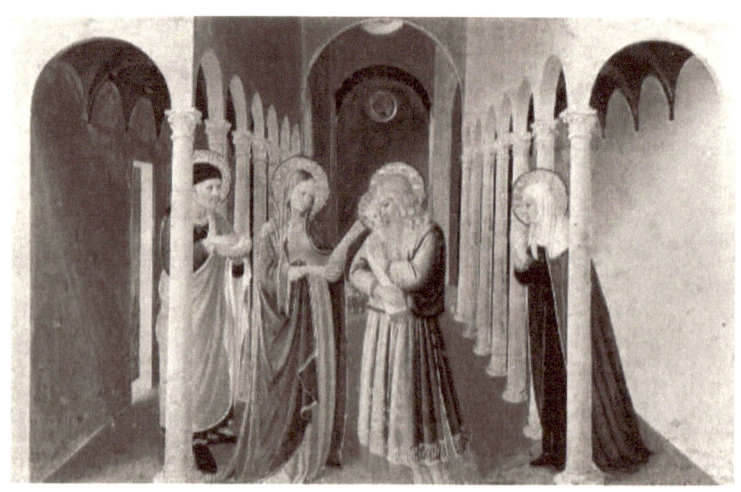

The Presentation of Christ in the Temple, 1433-1434
Tempera on panel

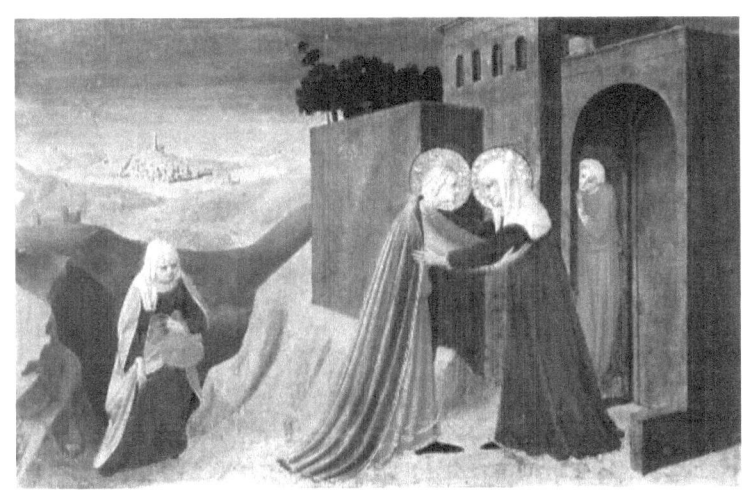

Visitation, 1433-1434
Tempera on panel

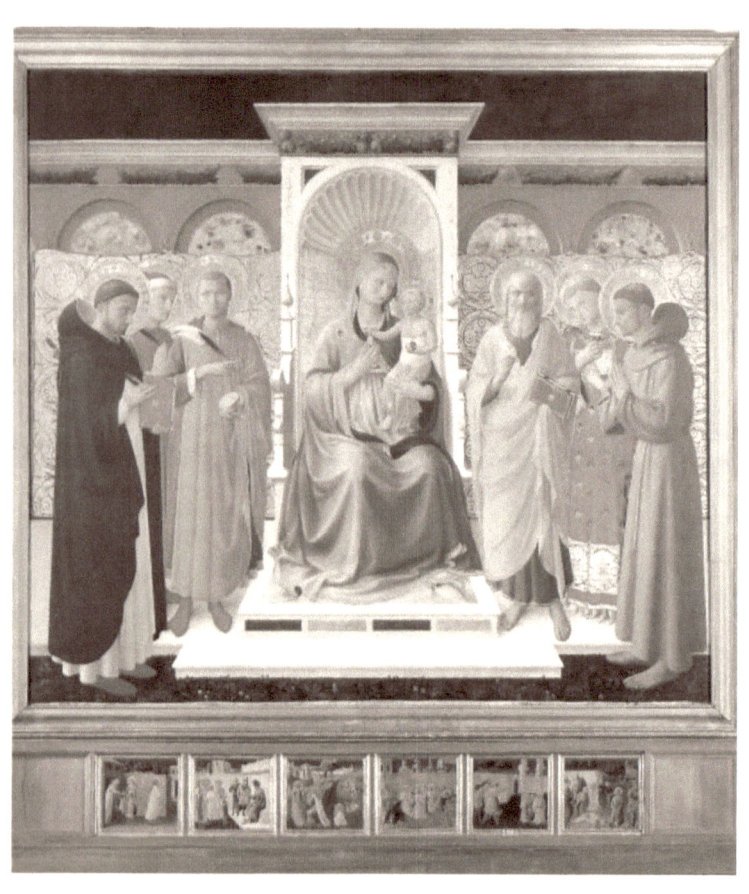

Annalena Altarpiece, c.1435
Tempera on panel

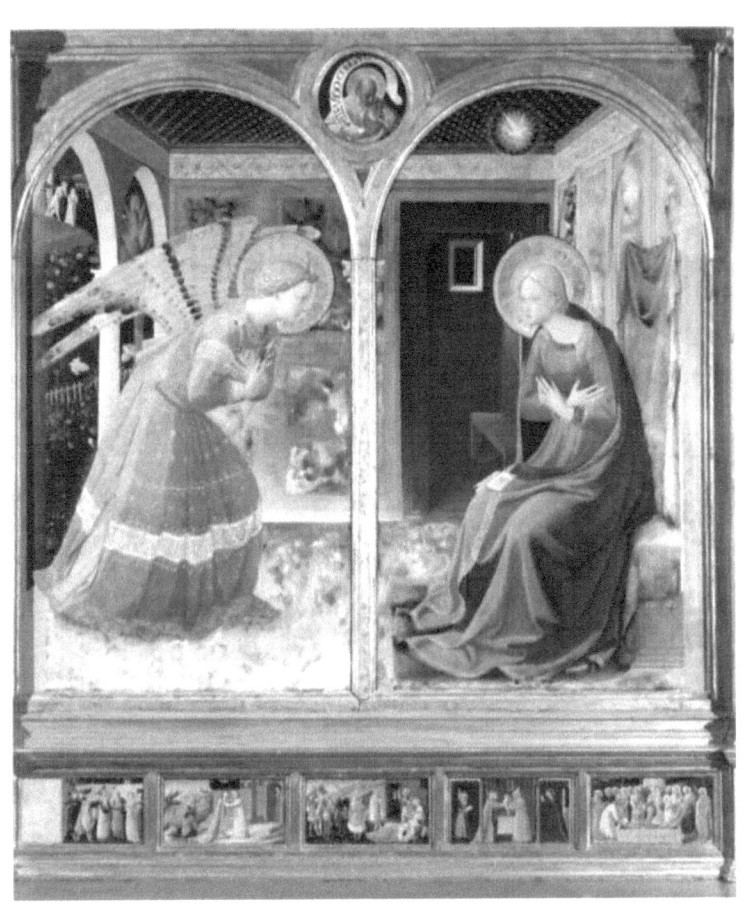

Annunciation, c.1435
Tempera on panel

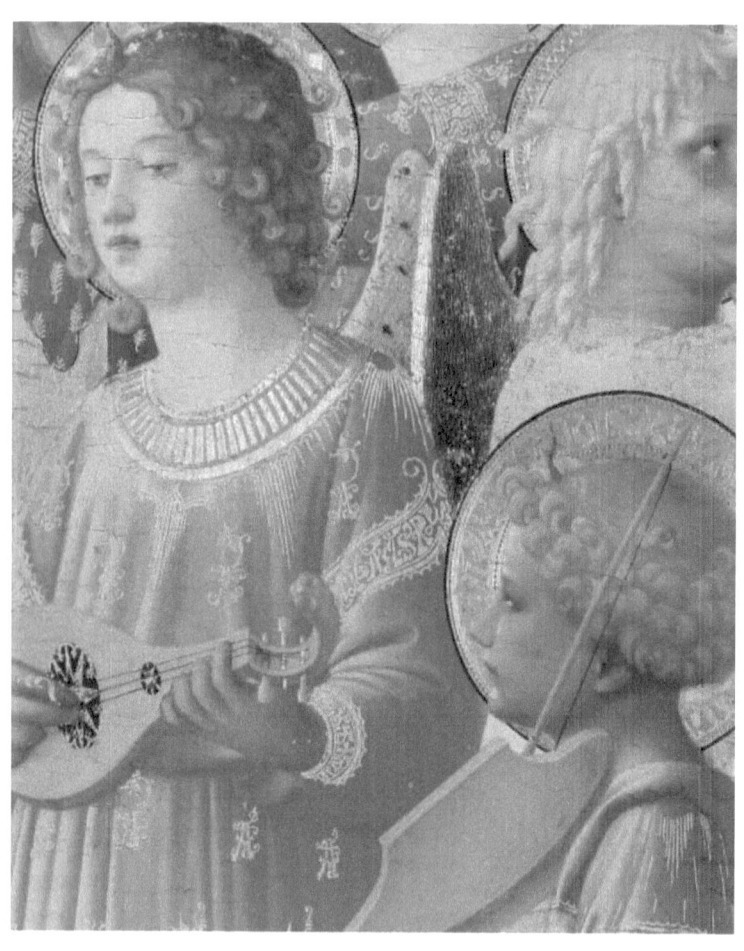

Coronation of the Virgin (detail), 1434-1435
Tempera on panel

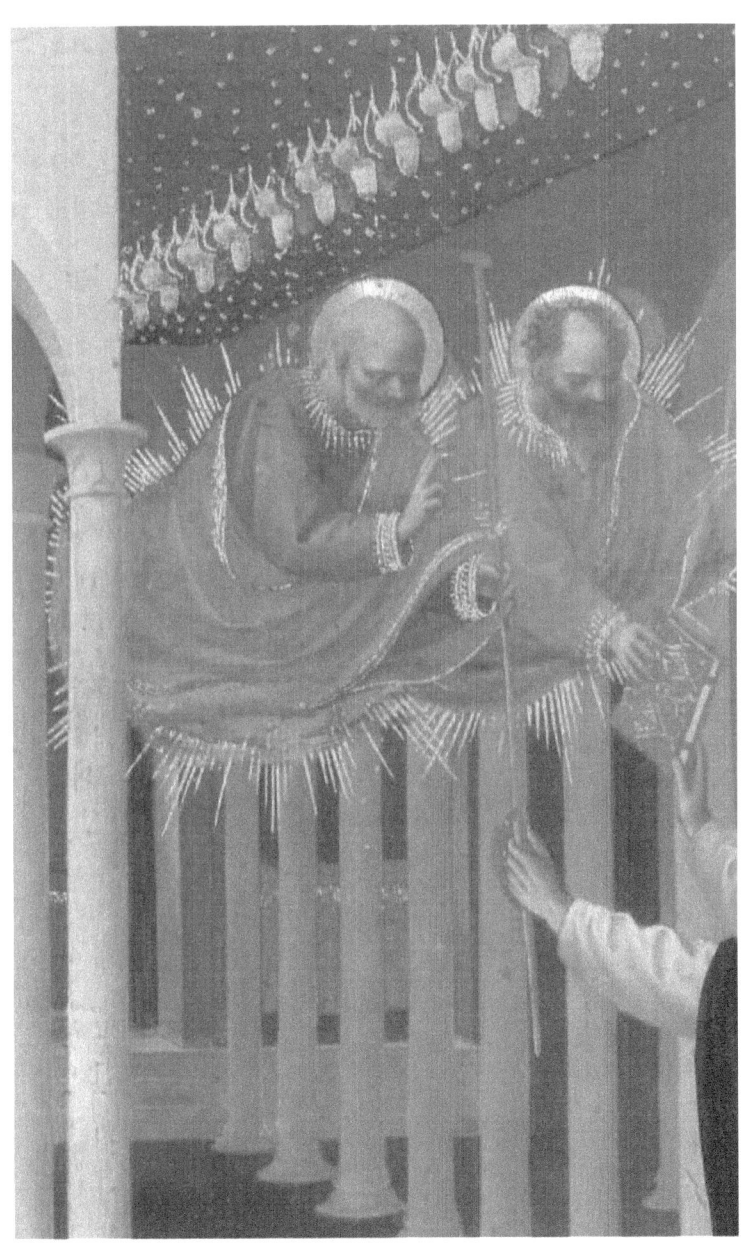

Coronation of the Virgin (detail), 1434-1435
Tempera on panel

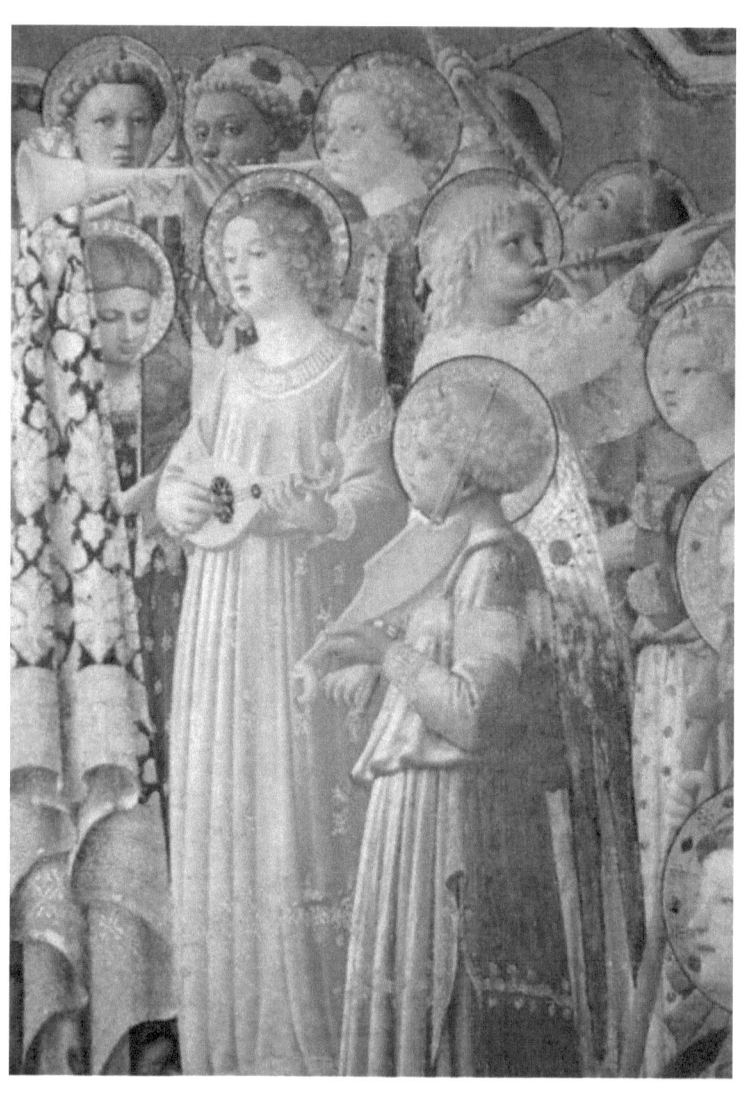

Coronation of the Virgin (detail), 1434-1435
Tempera on panel

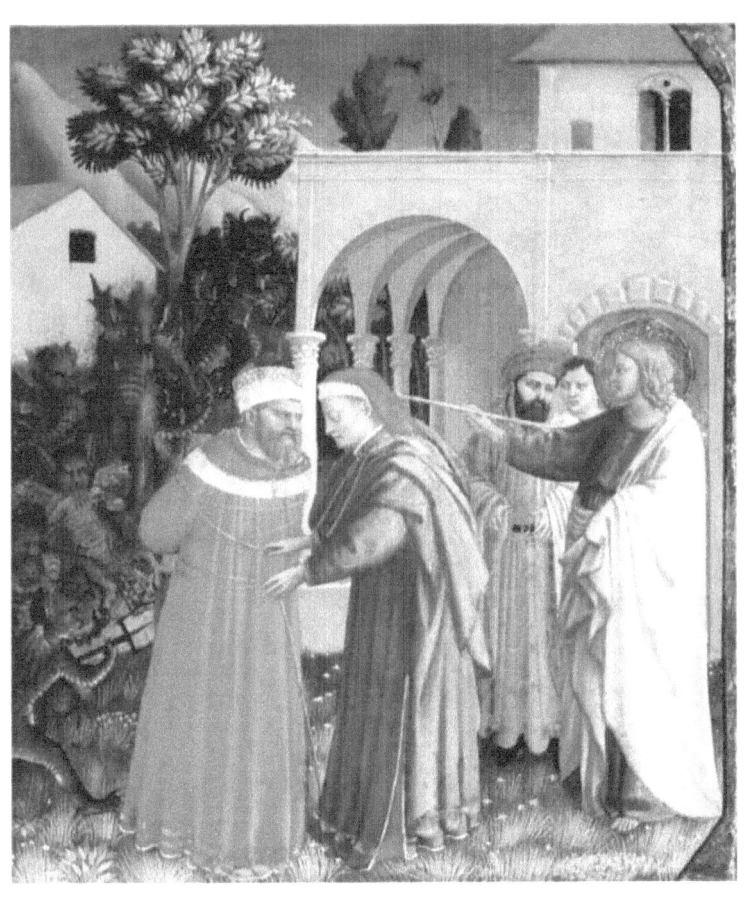

The Apostle St. James the Great Freeing the Magician
Hermogenes, 1434-1435
Tempera on panel

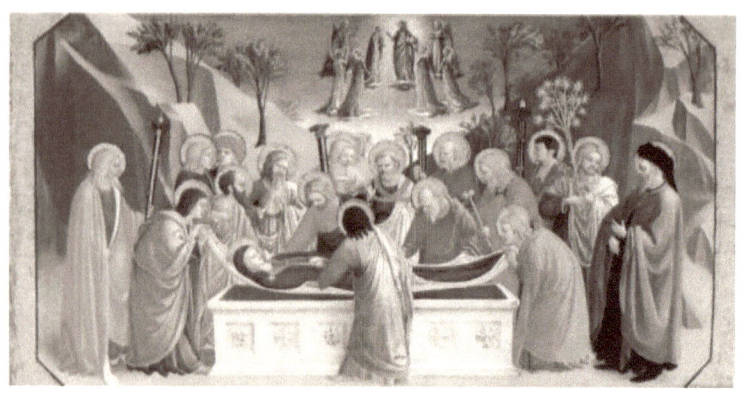

The Burial of the Virgin and the Reception of Her Soul in Heaven, 1434-1435, Tempera on panel

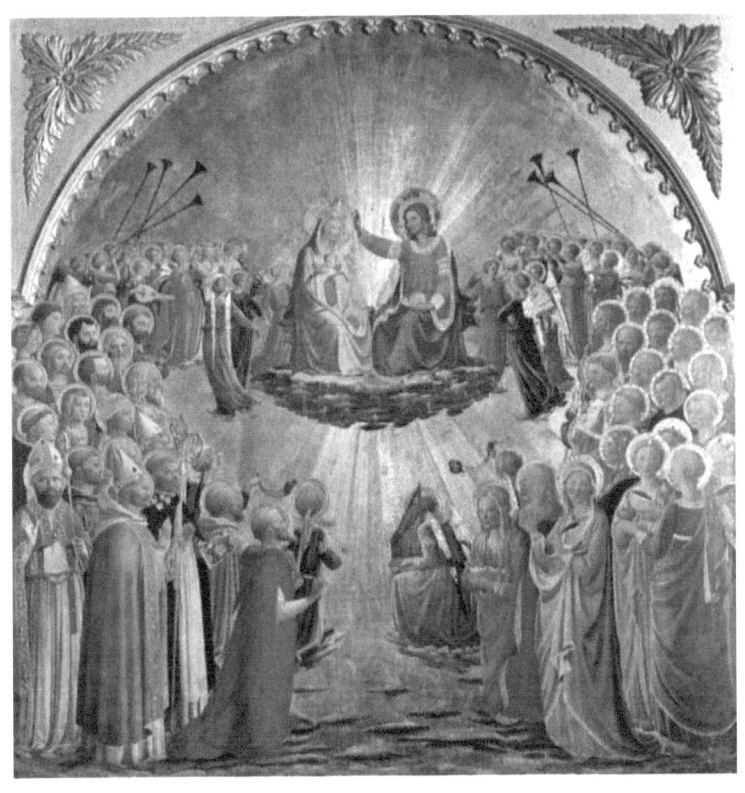

The Coronation of the Virgin, 1434-1435
Tempera on panel

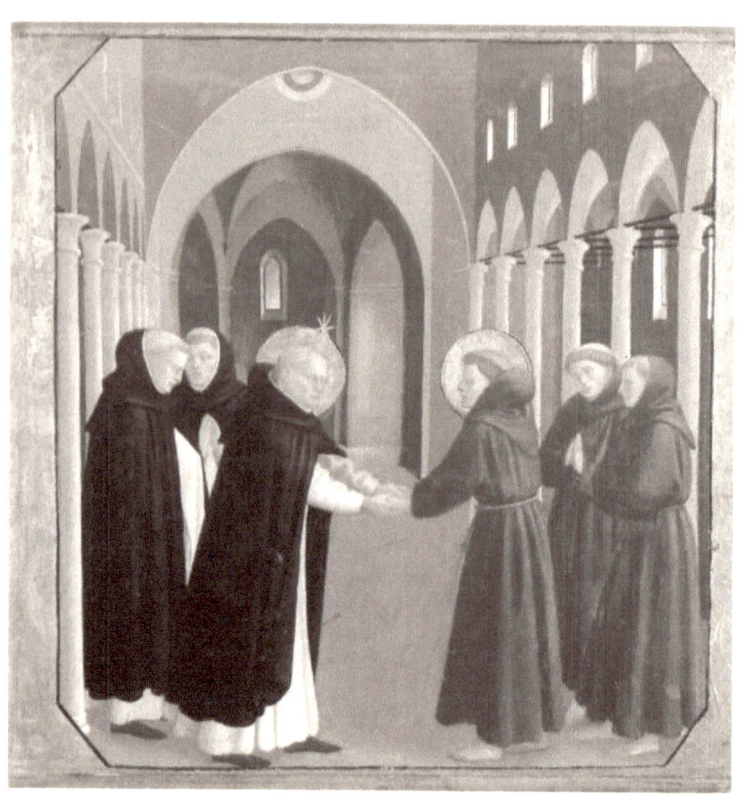

The Meeting of Sts. Dominic and Francis of Assisi,
1434-1435
Tempera on panel

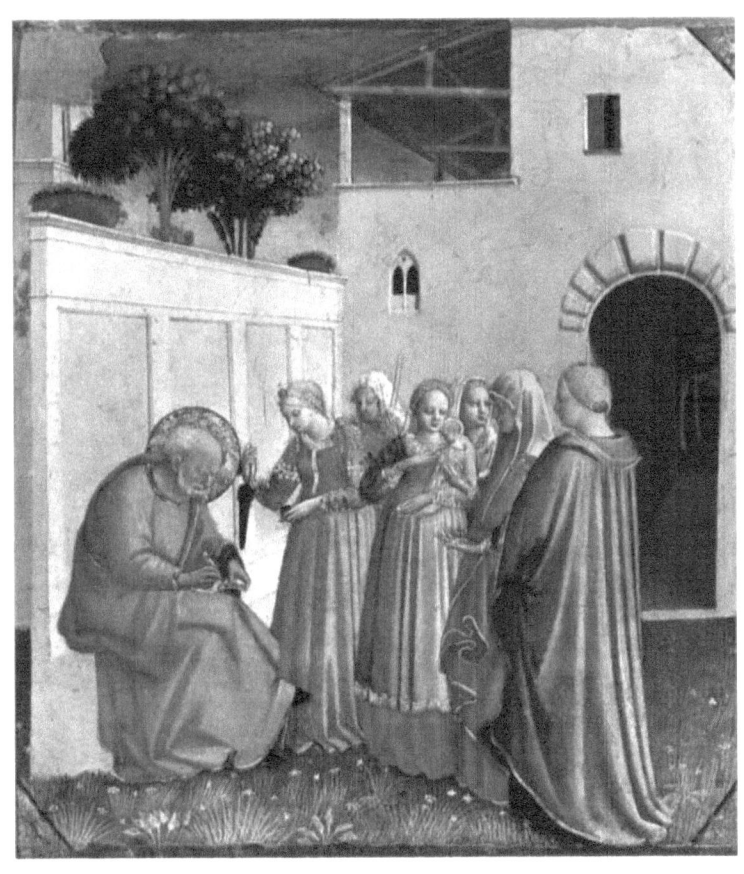

The Naming of St. John the Baptist, 1434-1435
Tempera on panel

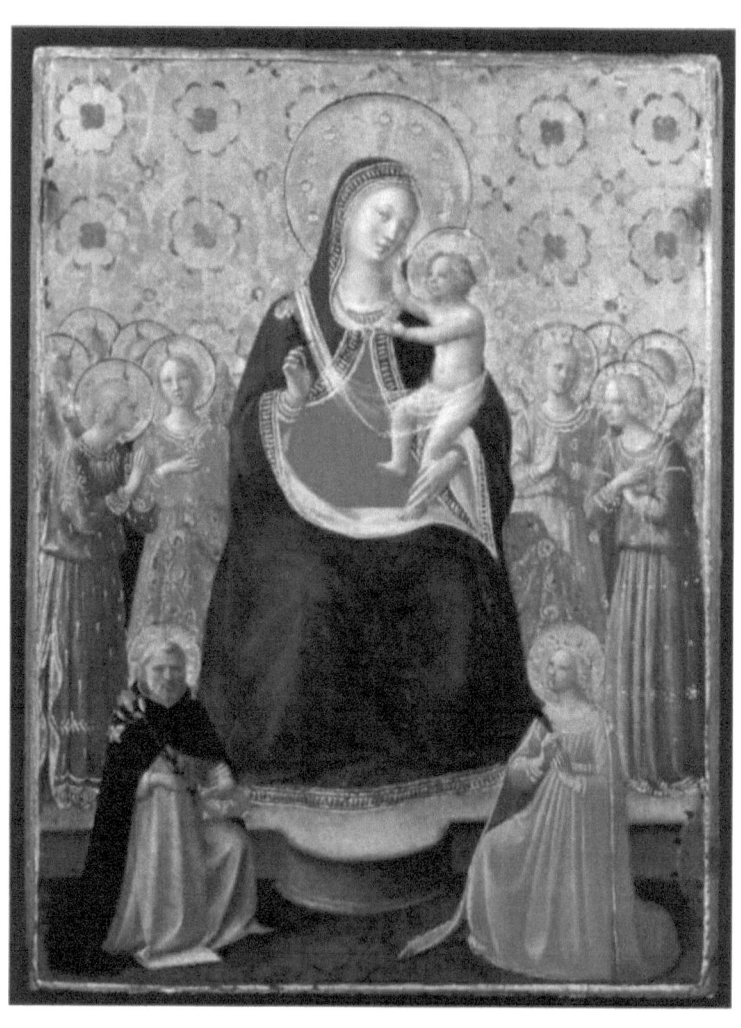

Virgin and Child with Sts. Dominic and Catherine of
Alexandria, c.1435
Tempera on panel

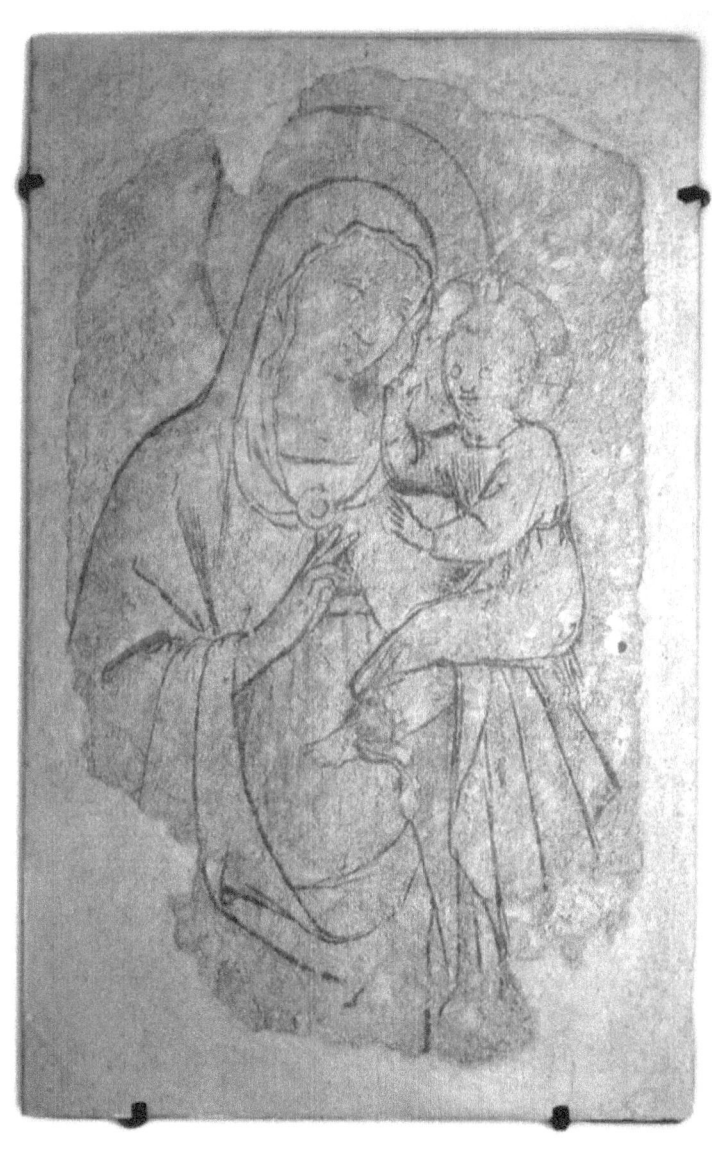

Virgin and Child, c. 1435
Detached sinopia, 116 x 76 cm

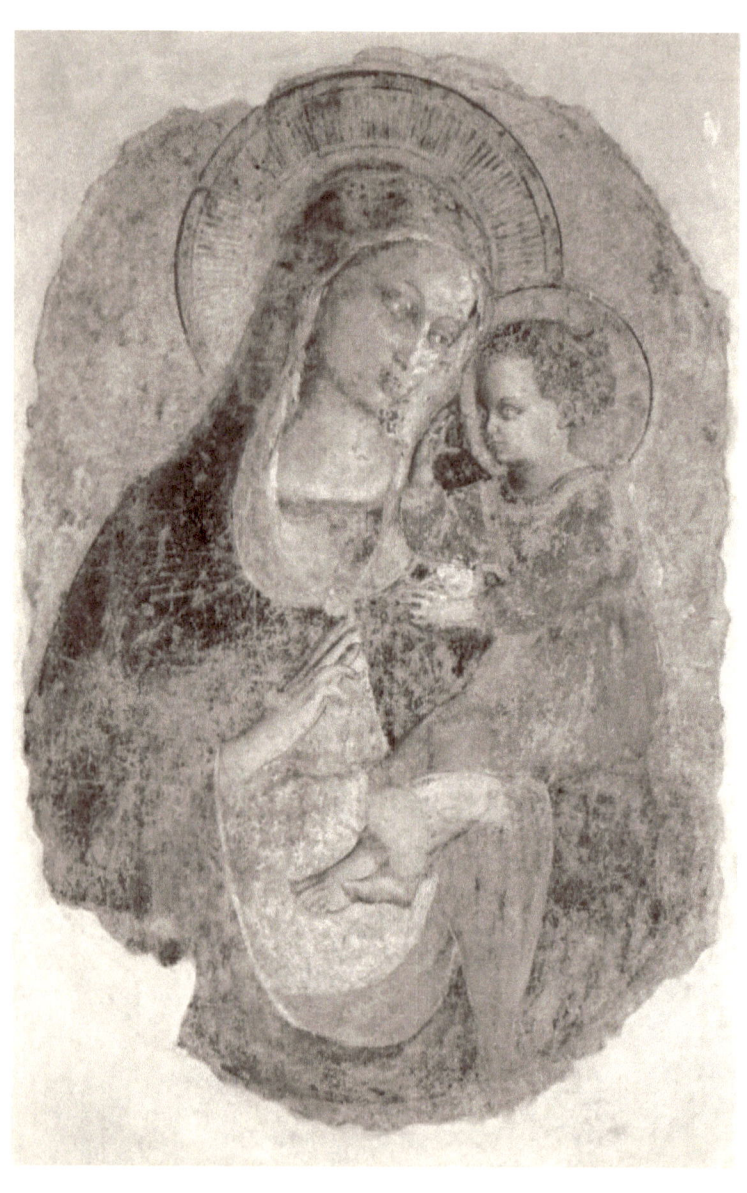

Madonna and Child, 1435
Detached fresco, 116 x 75 x 2 cm

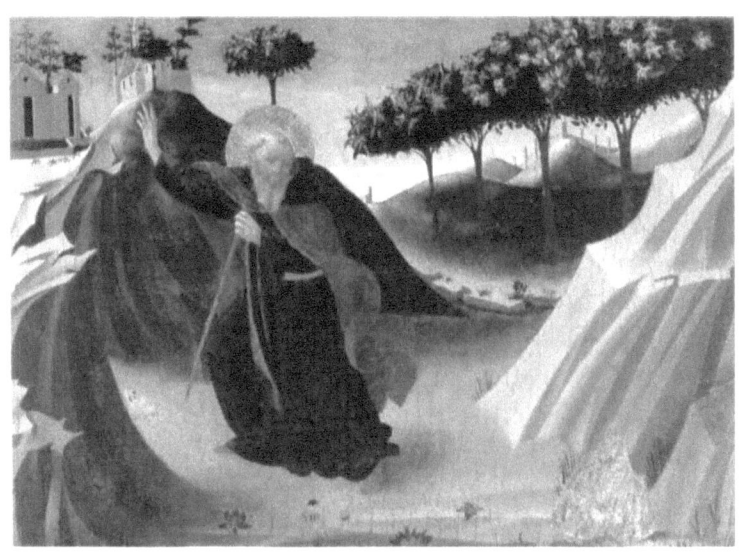

Saint Anthony the Abbot Tempted by a Lump of Gold,
1436, Tempera on panel

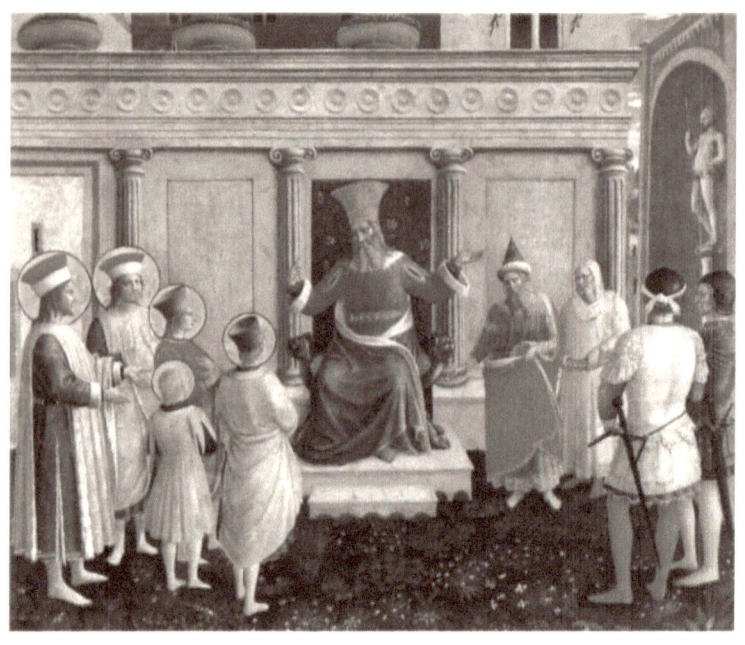

Saint Cosmas and Saint Damian before Lisius, 1438-1440, Tempera on panel

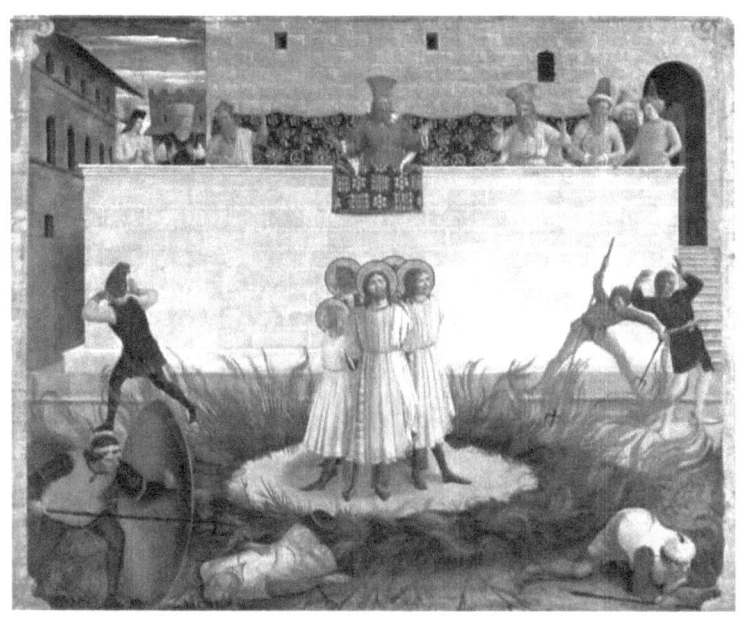

Saint Cosmas and Saint Damian Condamned, 1438-1440
Tempera on panel

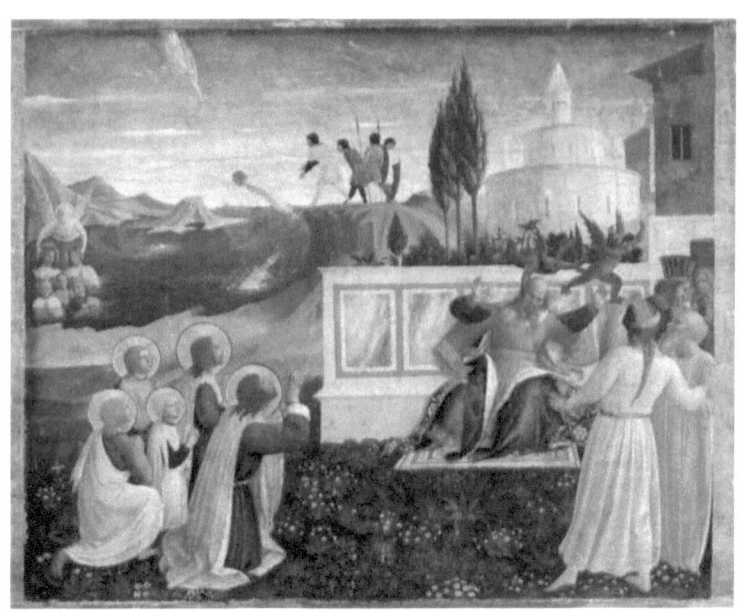

Saint Cosmas and Saint Damian Salvaged, 1438-1440
Tempera on panel

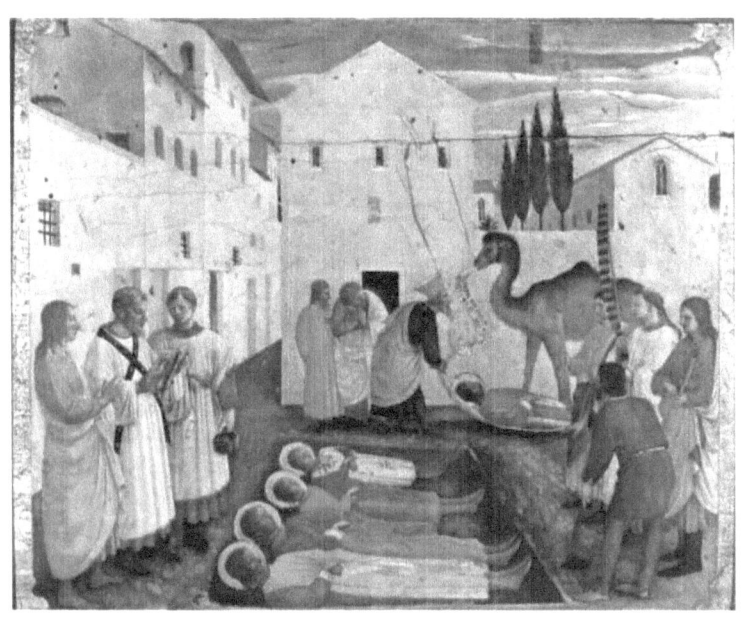

Sepulchring of Saint Cosmas and Saint Damian, 1438-1440
Tempera on panel

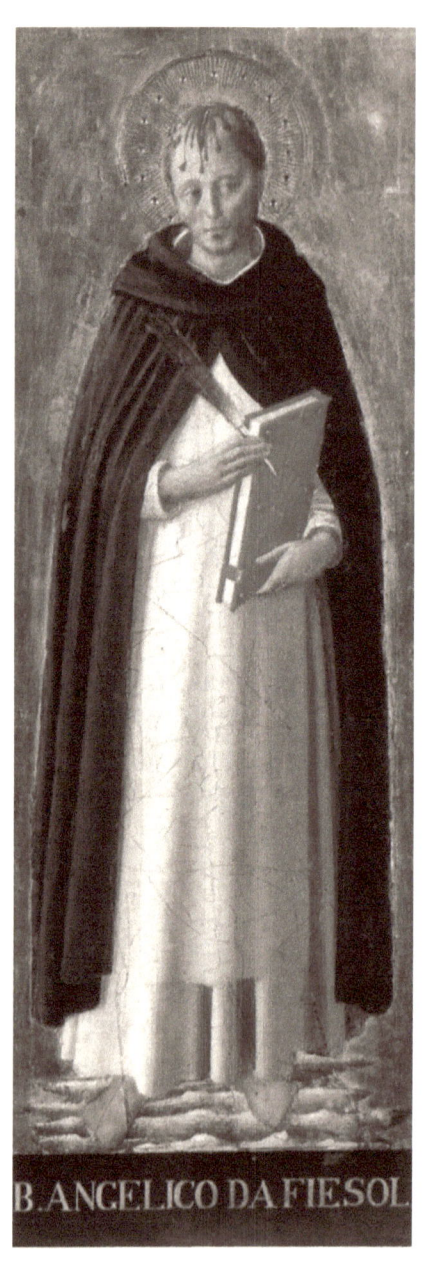

St. Peter Martyr, 1438-1440
Tempera on panel

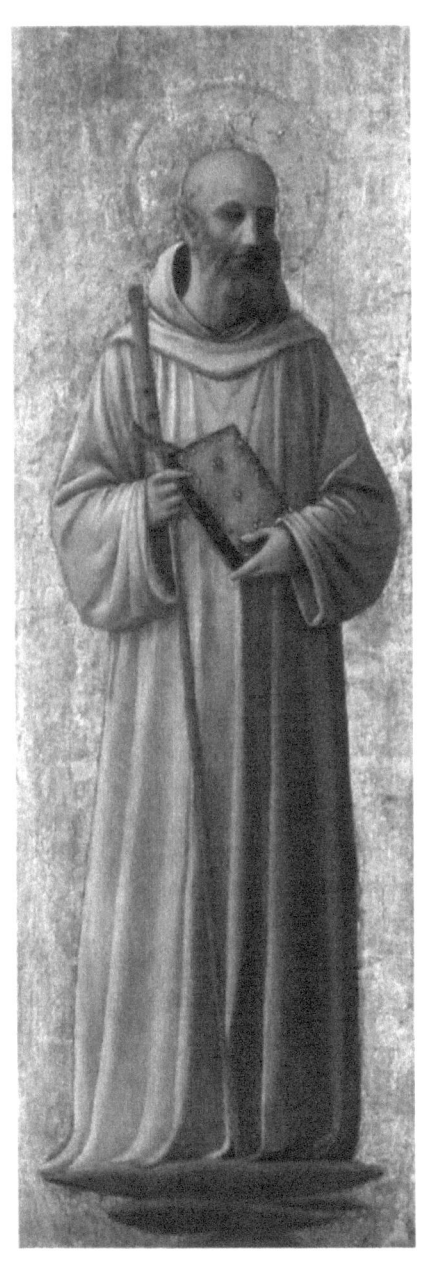

St. Romuald, 1438-1440
Tempera on panel

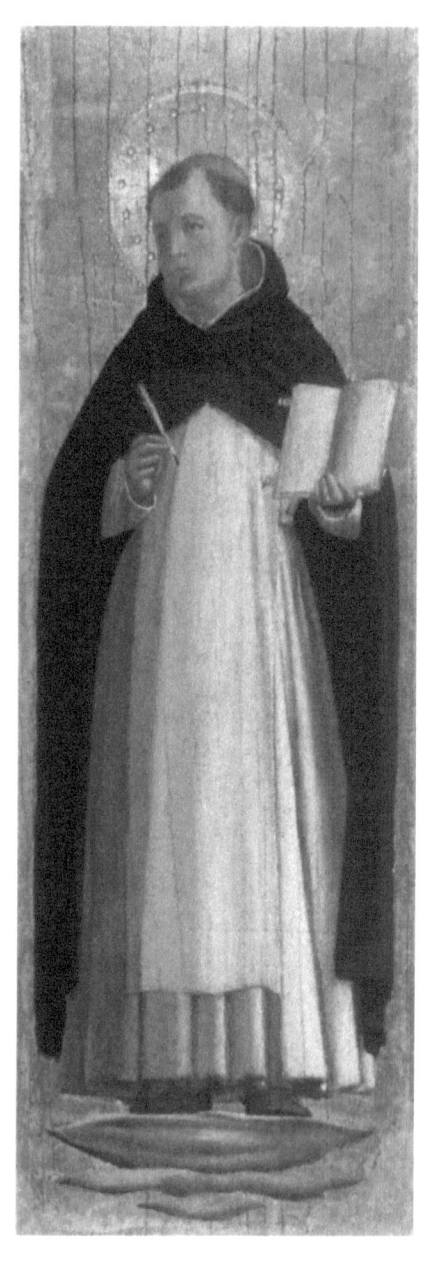

St. Thomas Aquinas, 1438-1440
Tempera on panel

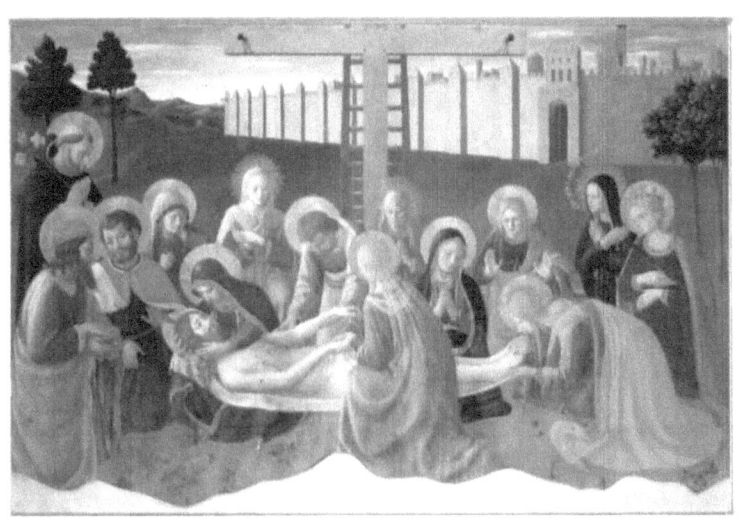

Lamentation over Christ, 1436-1441
Tempera on panel

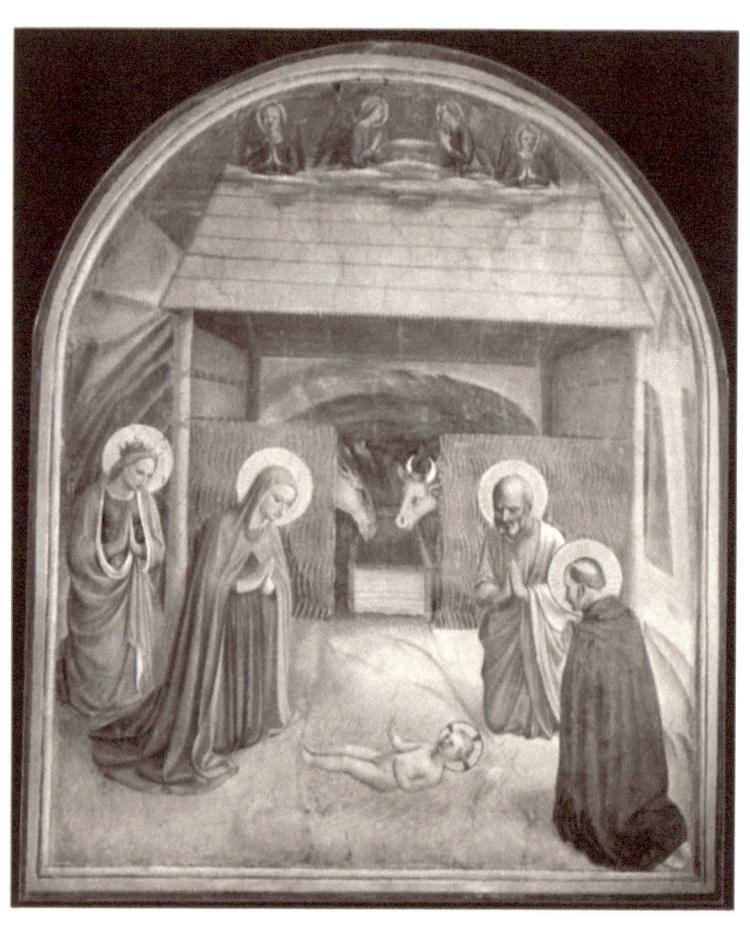

Nativity, 1440-1441
Tempera on panel

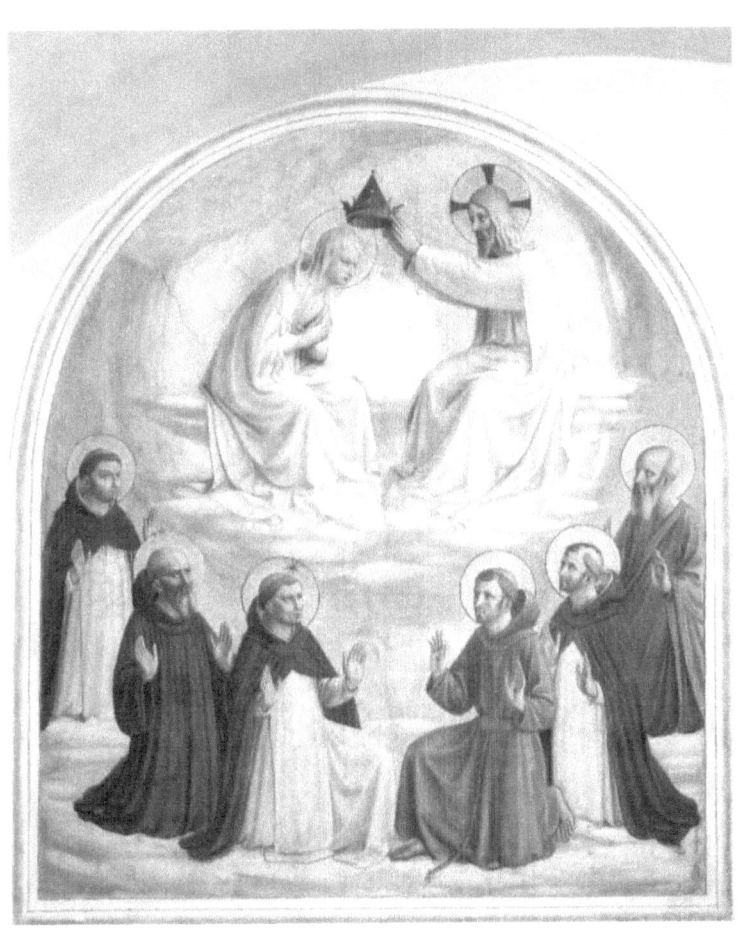

The Coronation of the Virgin , 1440-1441
Fresco

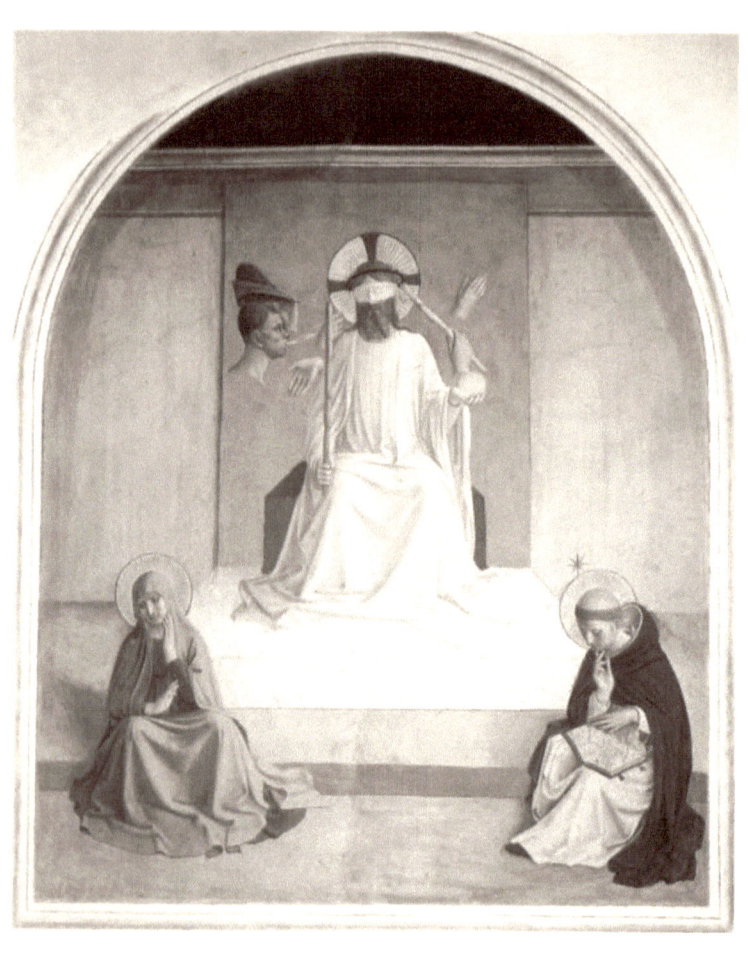

The Mocking of Christ, 1440-1441
Tempera on panel

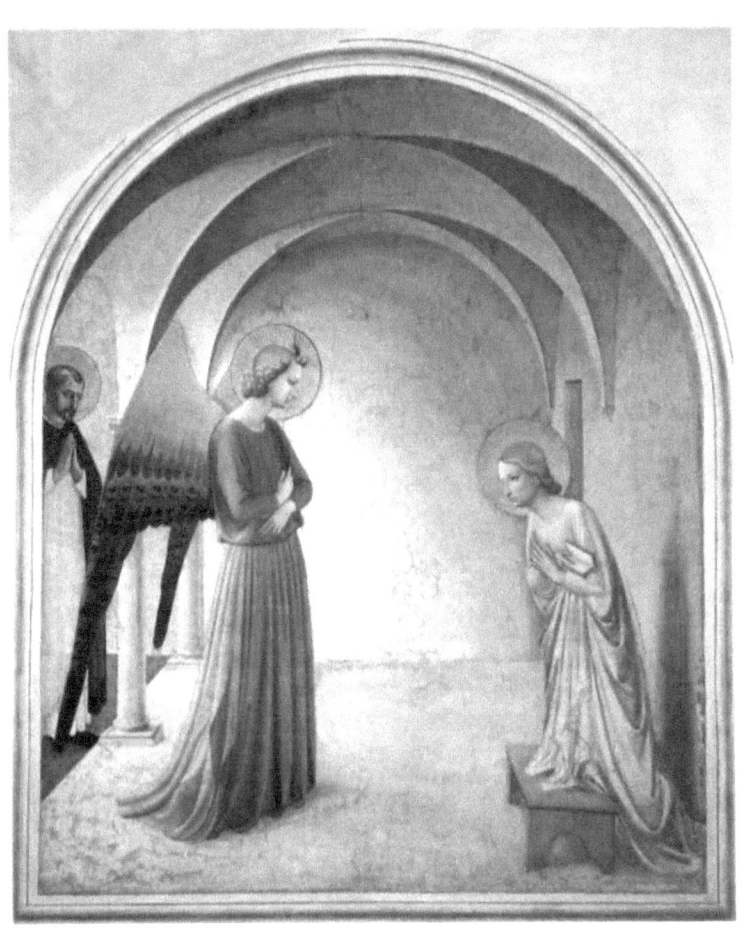

Annunciation, 1440-1442
Fresco

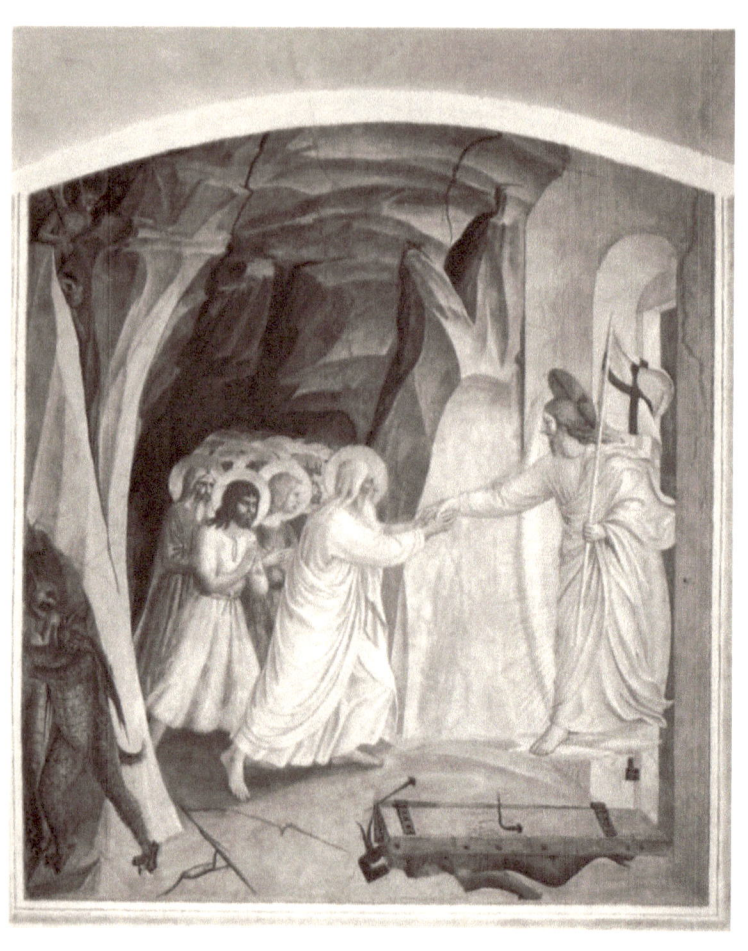

Christ in Limbo, 1441-1442
Fresco

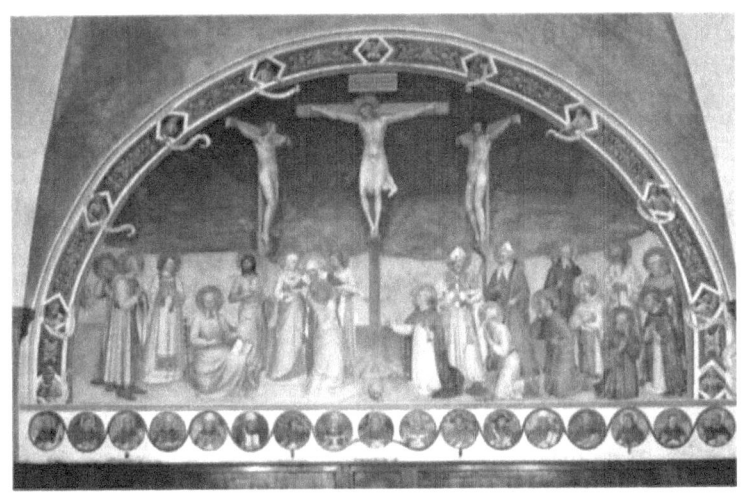

Crucifixion and Saints, 1441-1442
Fresco

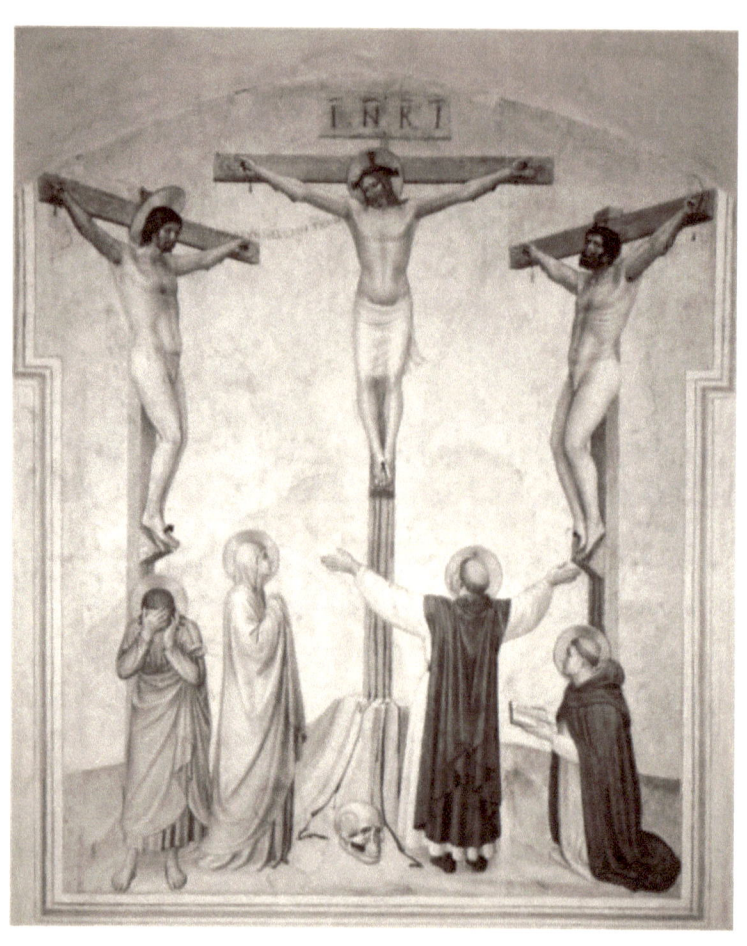

Crucifixion with Mourners and Sts. Dominic and
Thomas Aquinas, 1441-1442
Fresco

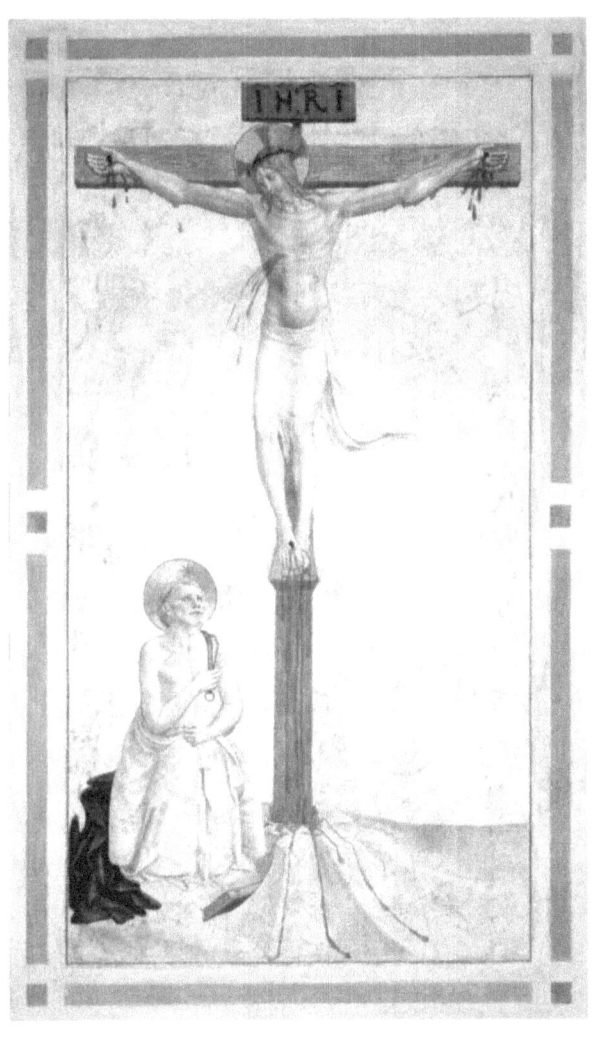

Crucifixion with St. Dominic Flagellating Himself, c.1442
Fresco

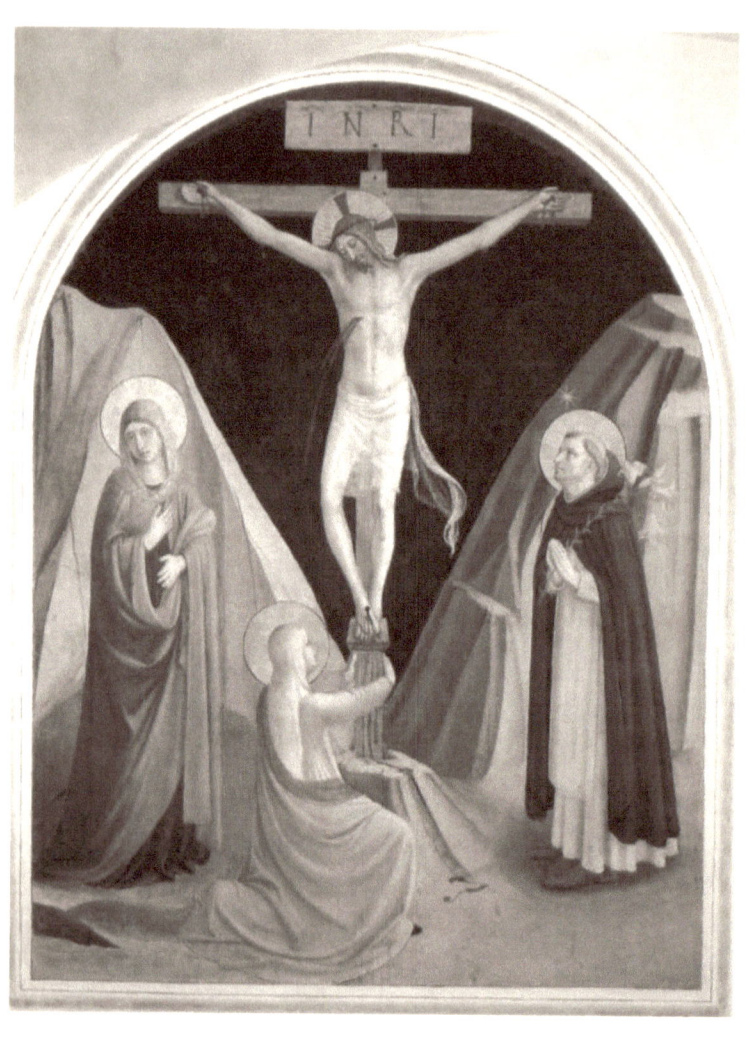

Crucifixion with the Virgin, Mary Magdalene and St. Dominic, 1441-1442
Fresco

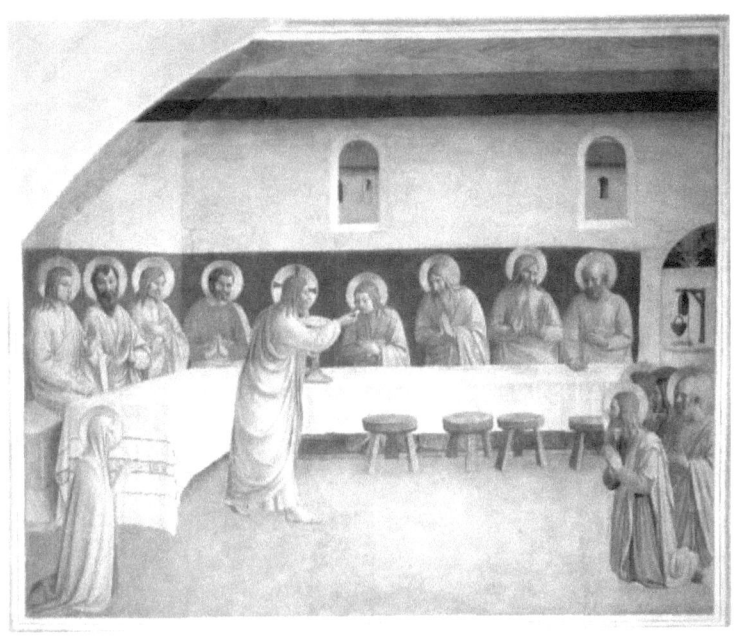

Institution of the Eucharist, 1441-1442
Fresco

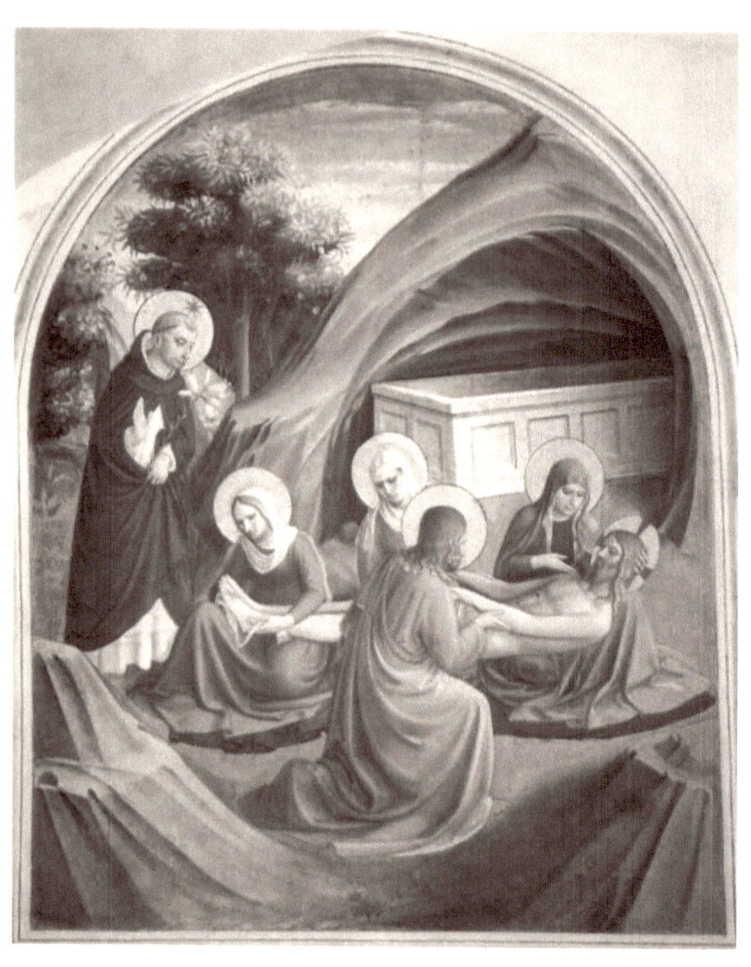

Lamentation over Christ, 1440-1442
Fresco

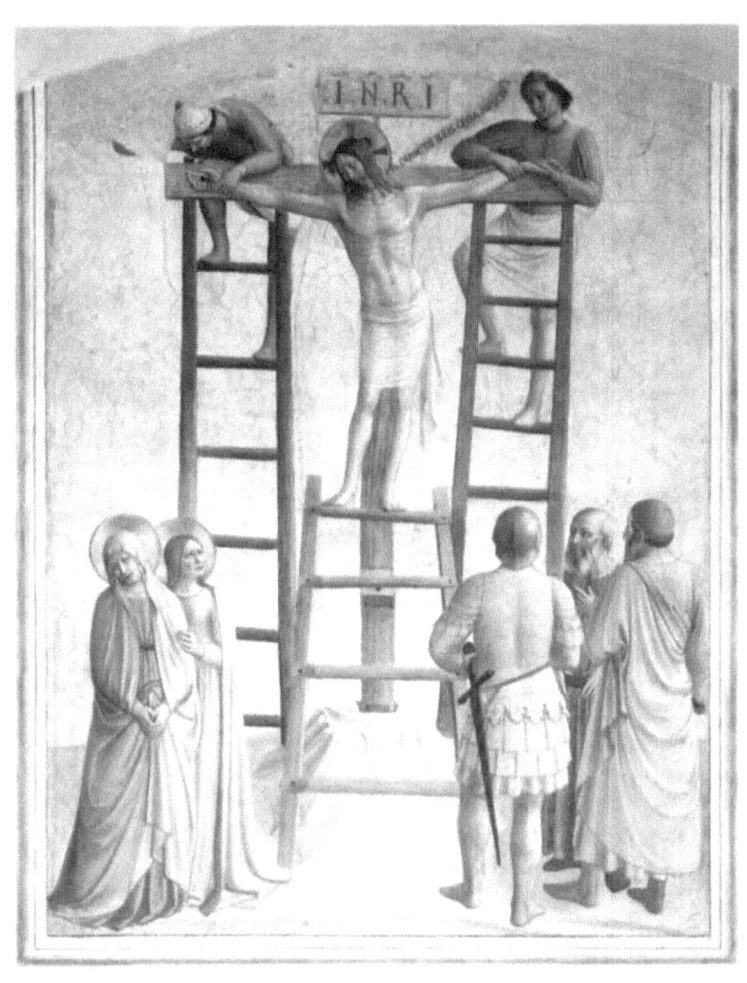

Nailing of Christ to the Cross, 1441-1442
Fresco

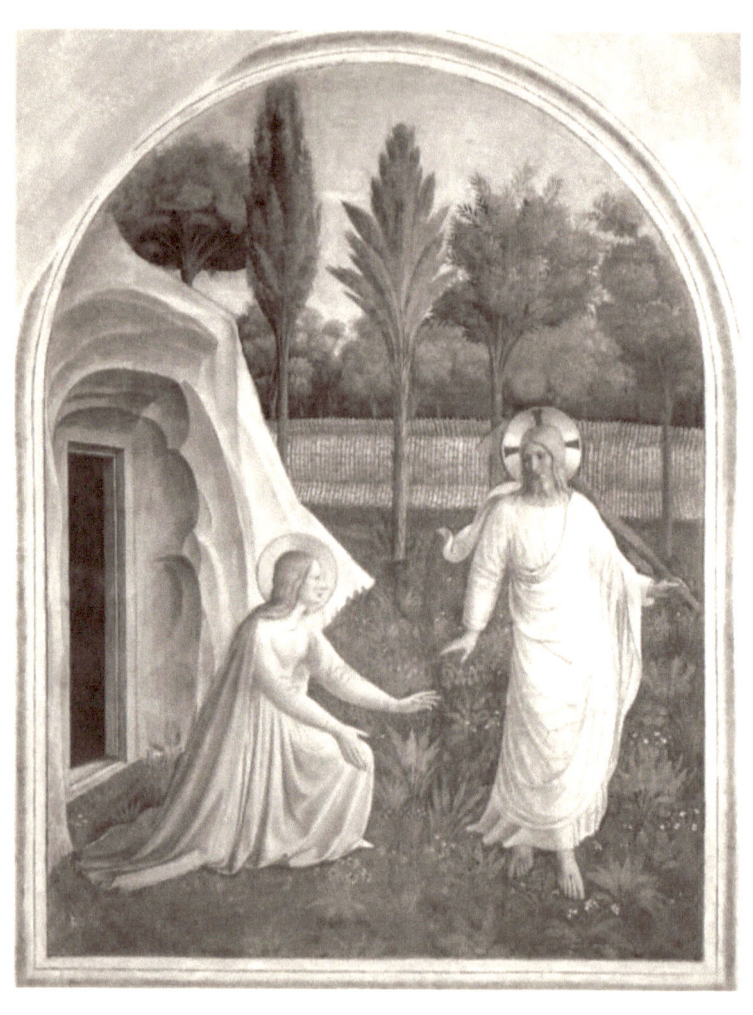

Noli Me Tangere, 1440-1442
Fresco

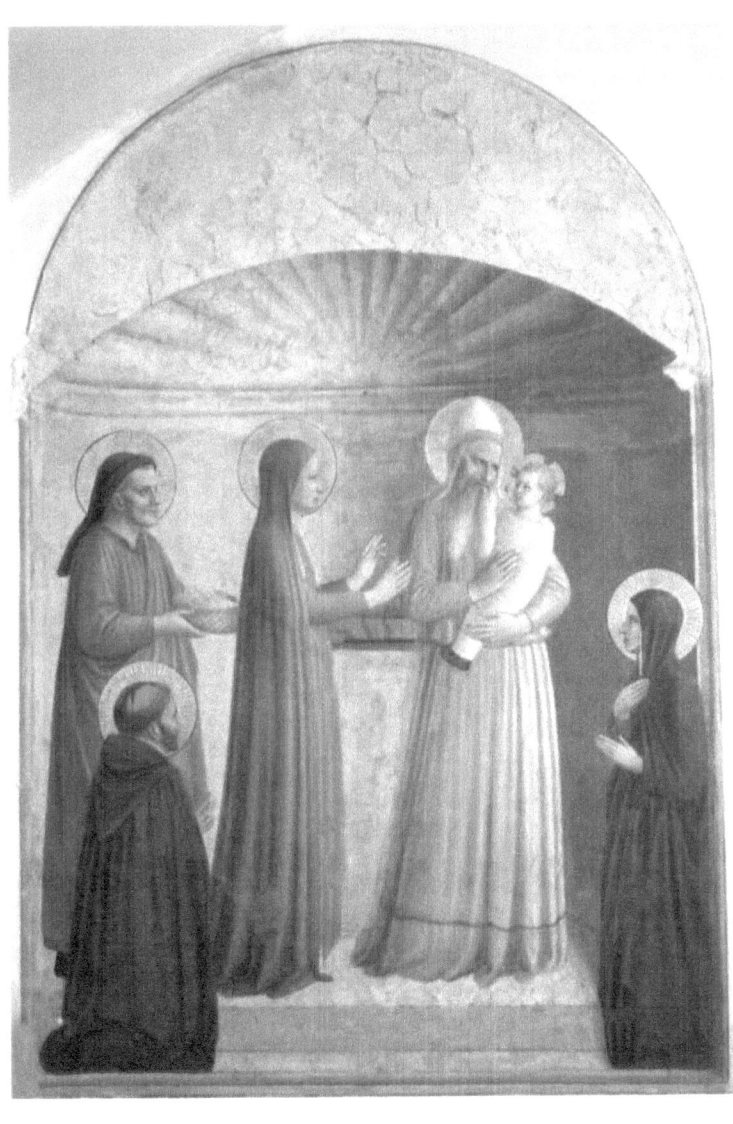

Presentation of Jesus in the Temple, 1440-1442
Fresco

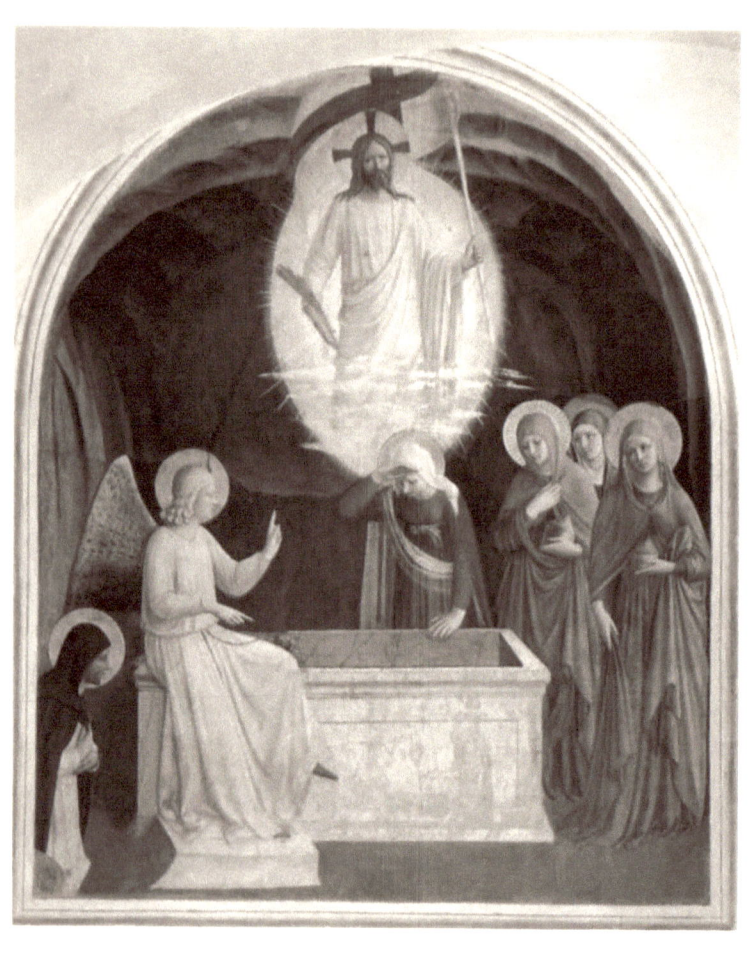

Resurrection of Christ and Women at the Tomb, 1440-1442
Fresco

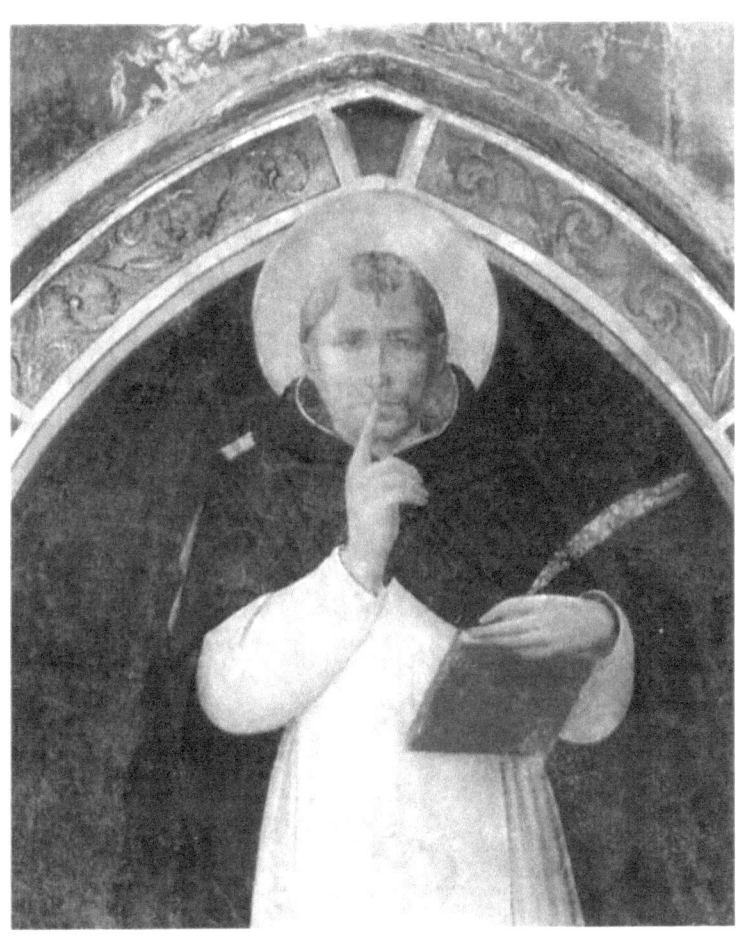

St. Peter Martyr, 1441-1442
Fresco

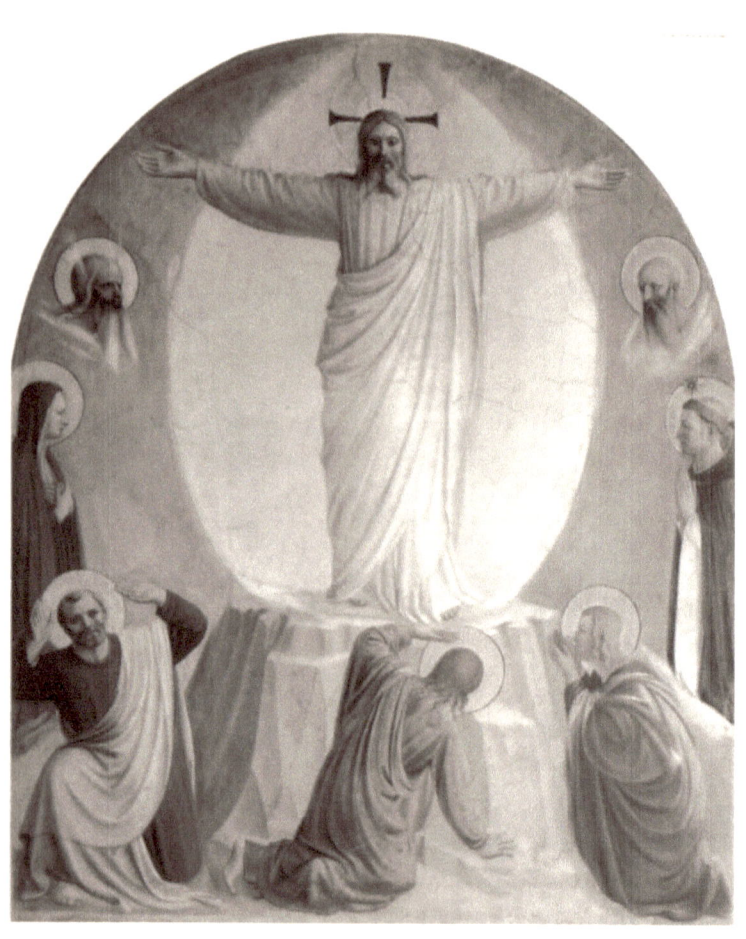

Transfiguration, 1440-1442
Fresco

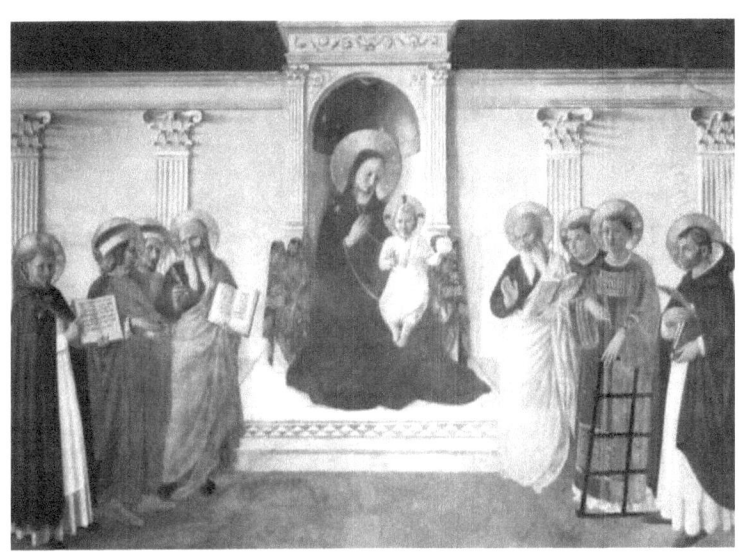

Sacred Conversation, 1443, Fresco

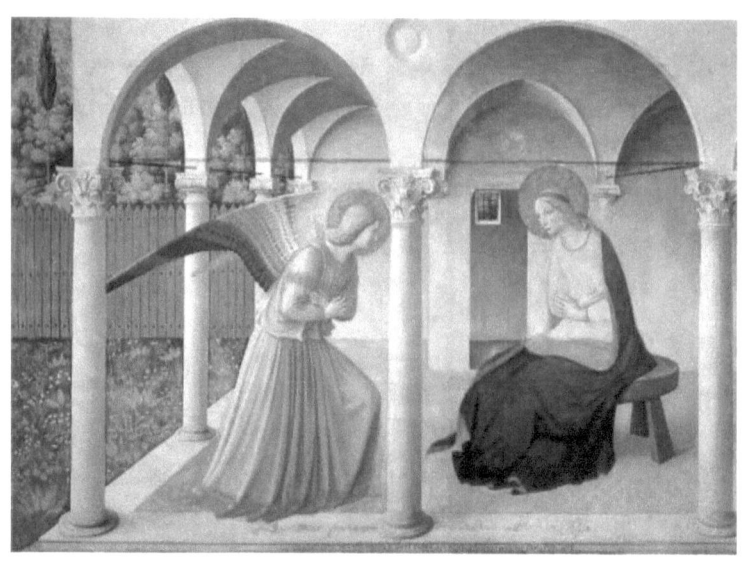

Sacred Conversation, 1443, Fresco

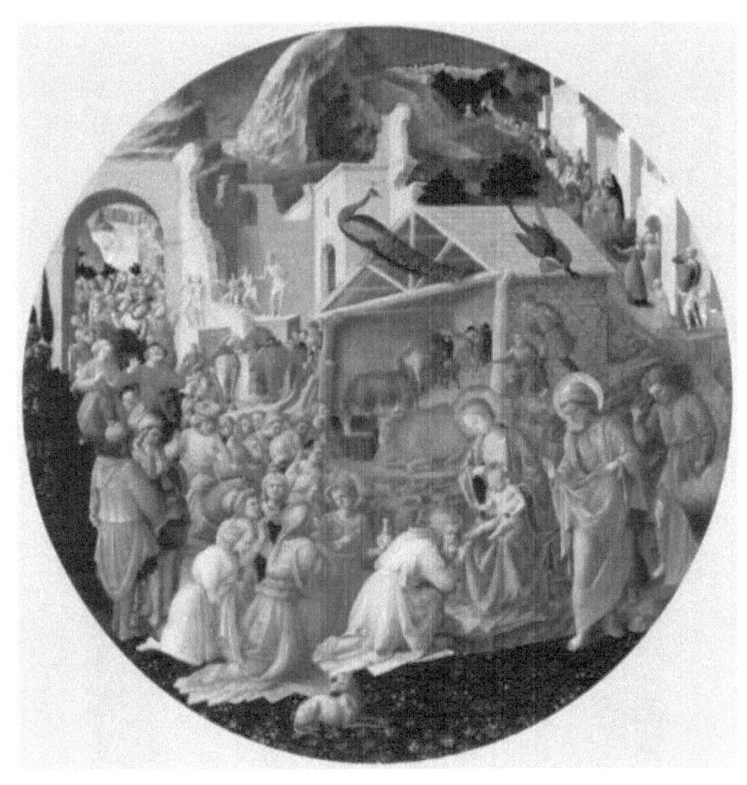

Adoration of the Magi, c.1445
Fresco

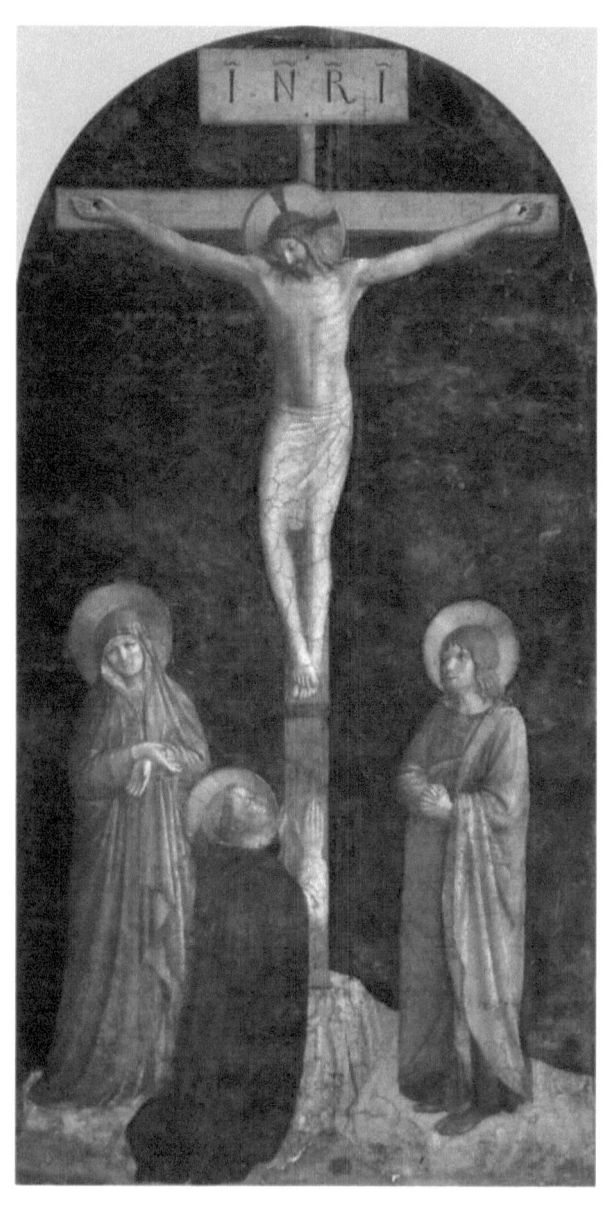

Crucifixion with St. Dominic, 1440-1445
Fresco

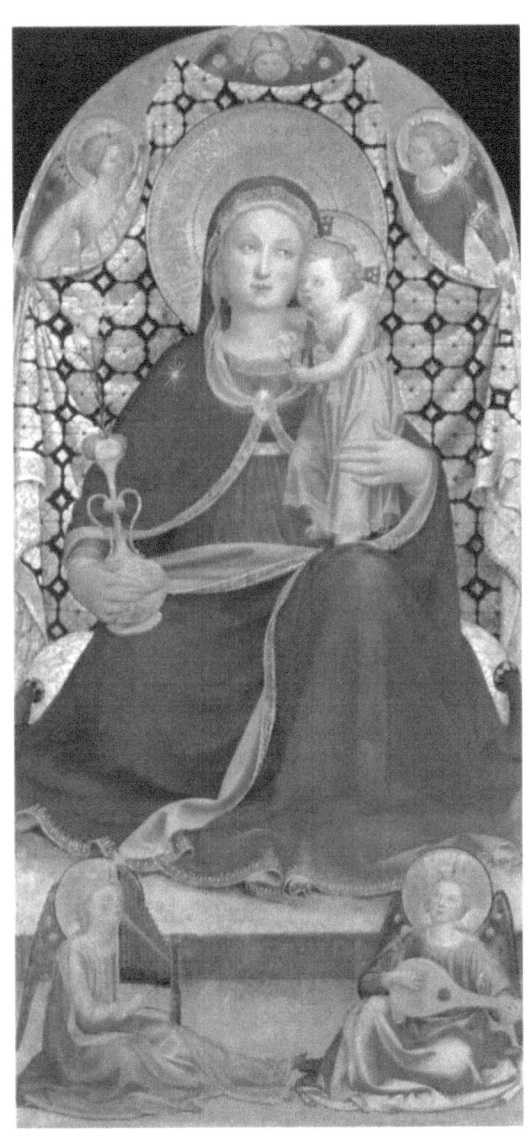

The Virgin of Humility, 1445
Tempera on panel

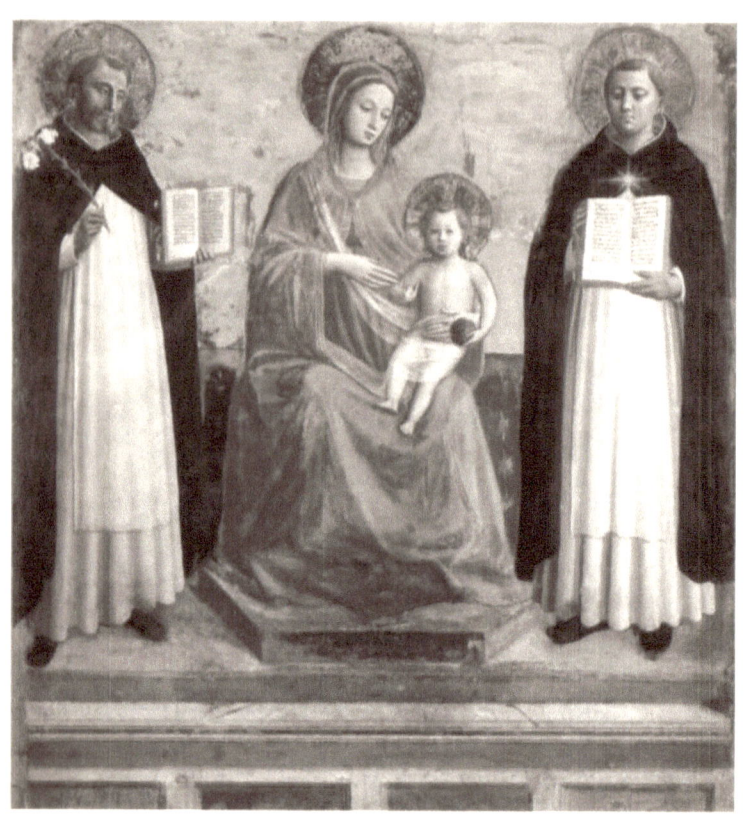

Virgin and Child with Sts. Dominic and Thomas
Aquinas, c.1445
Fresco

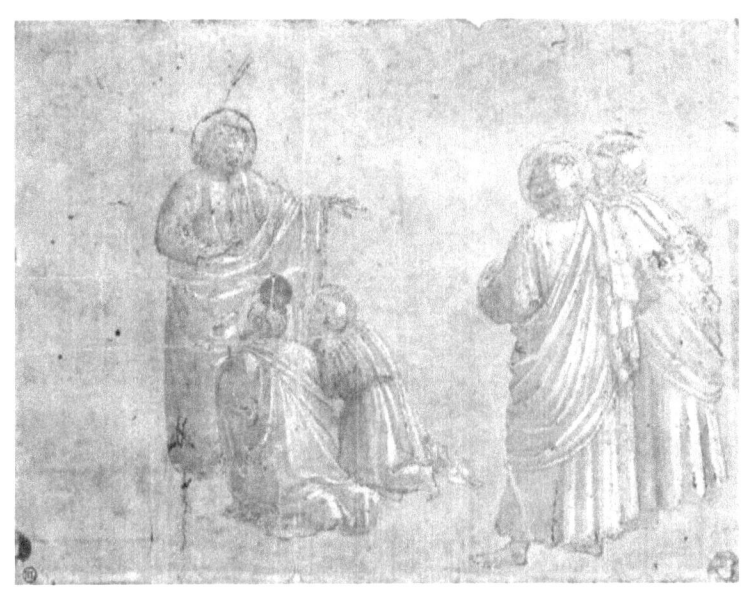

Institution of the Eucharist, 1445-46
Pen and wash on pink tinted paper, 135 x 179 mm

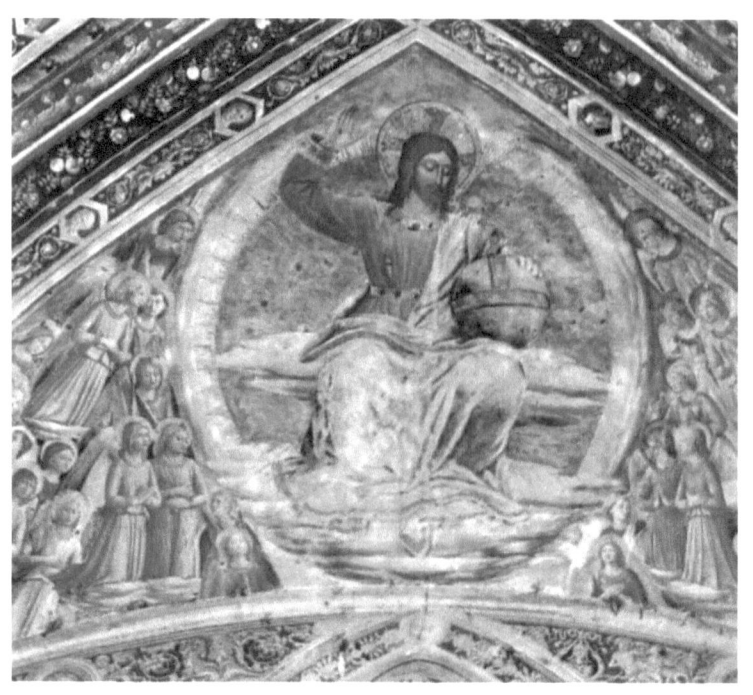

Christ the Judge, 1447
Fresco

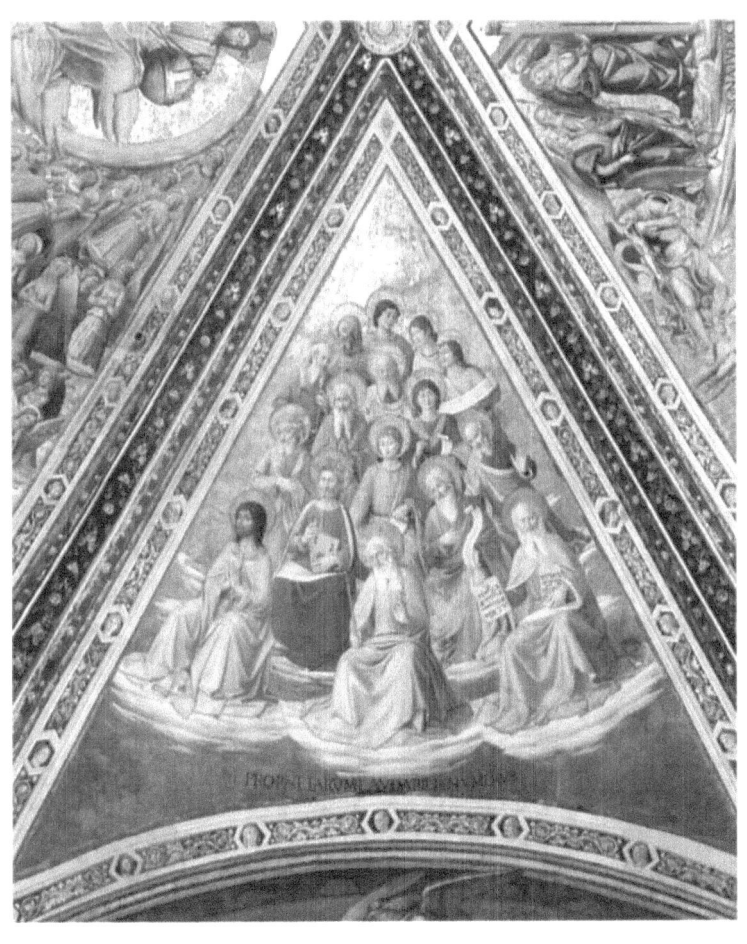

Prophets, 1447
Fresco

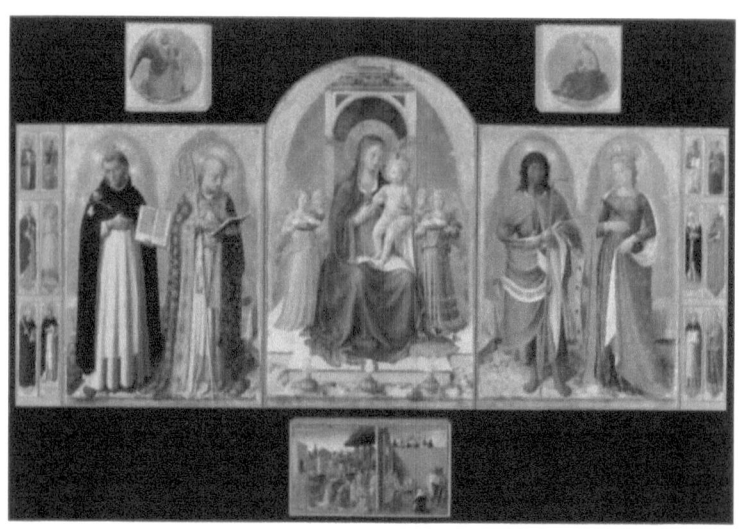

Perugia Altarpiece, 1447-1448
Fresco

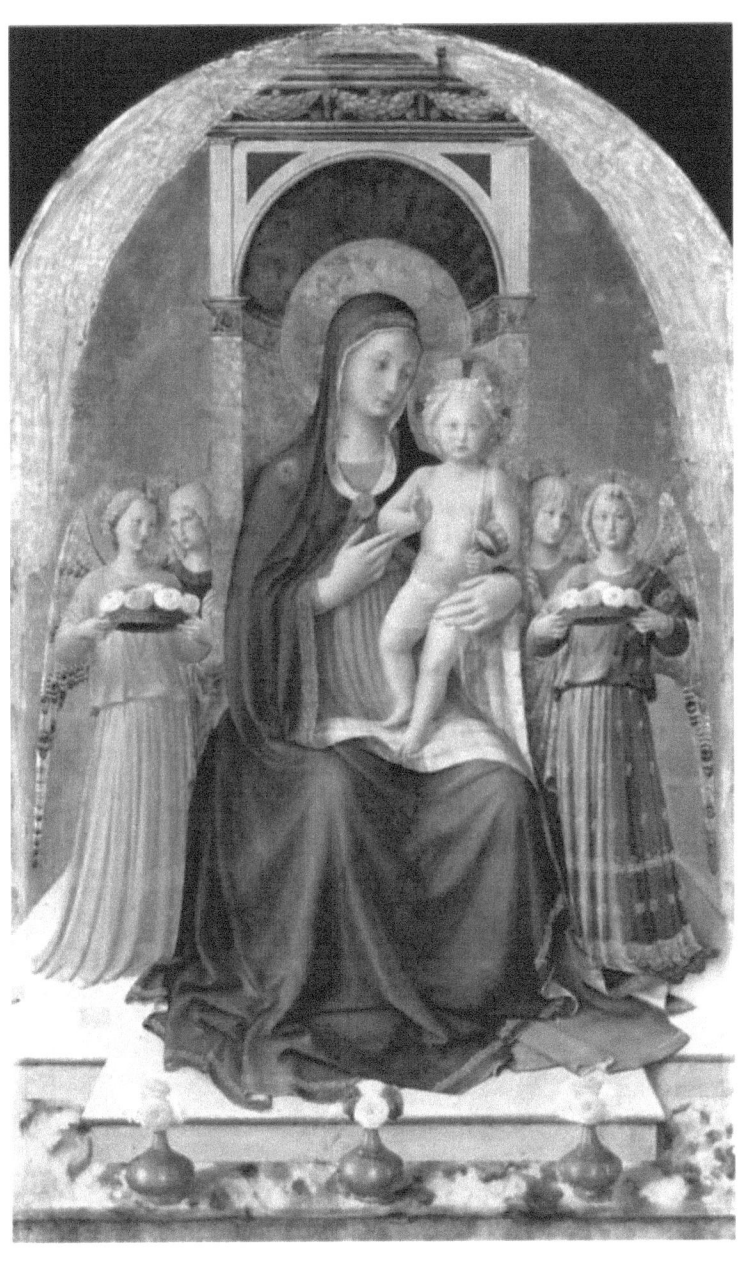

Perugia Altarpiece (central panel), 1447-1448
Fresco

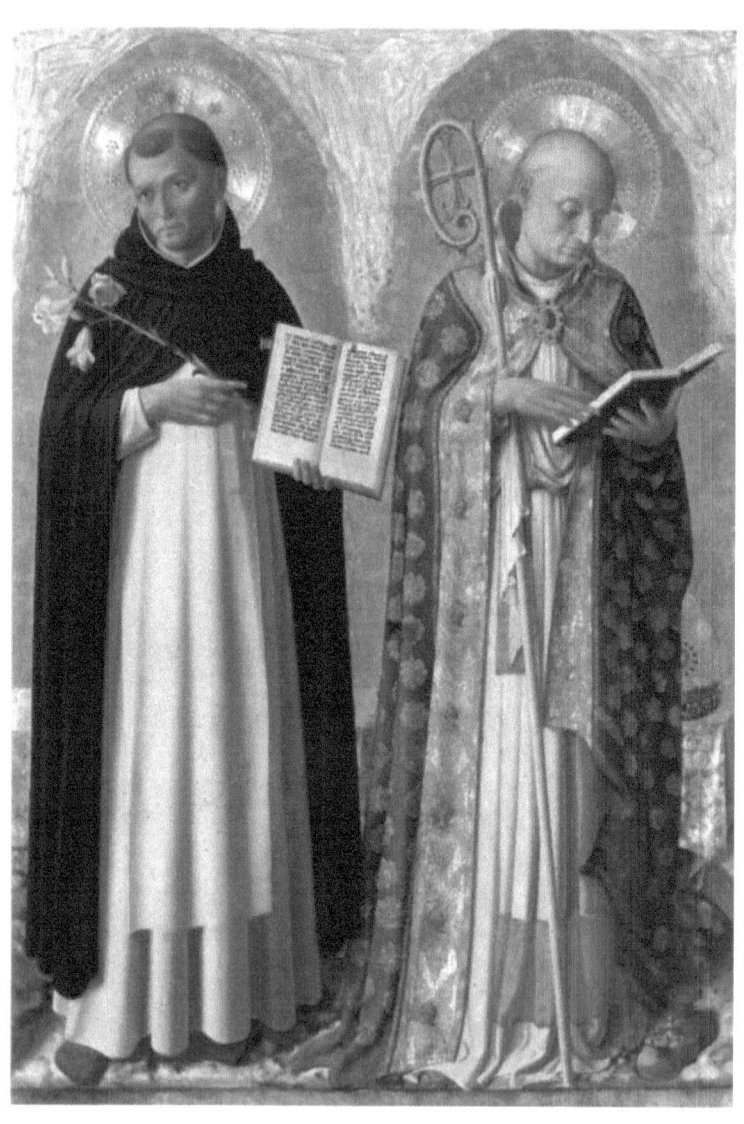

Perugia Altarpiece (left panel), 1447-1448
Fresco

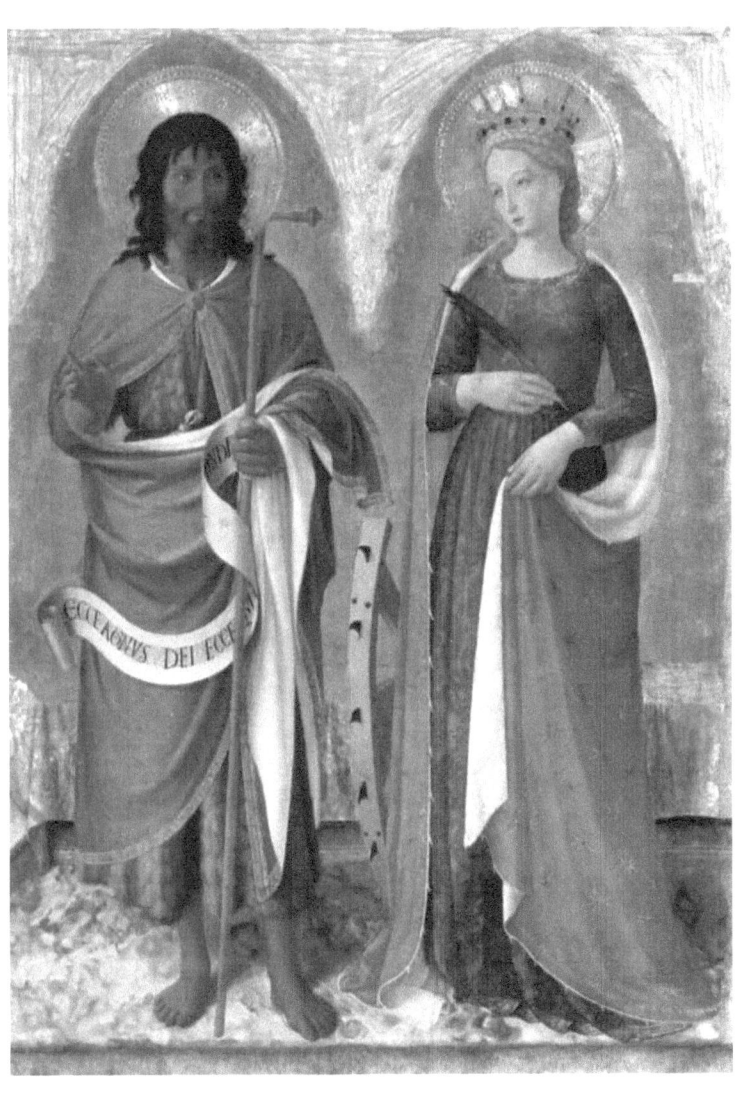

Perugia Altarpiece (right panel), 1447-1448
Tempera on panel

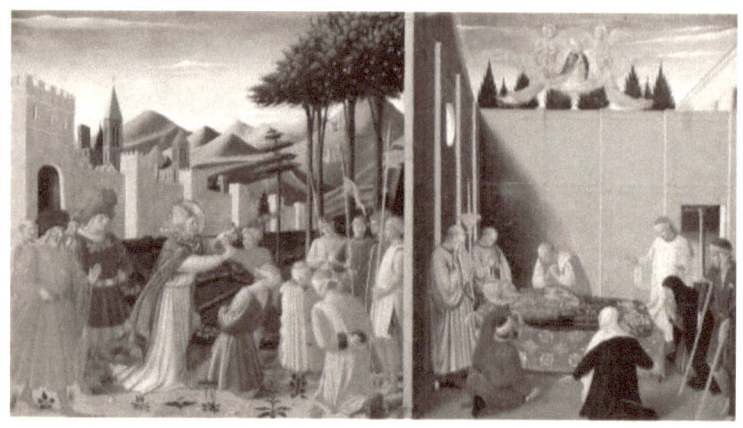

The Story of St. Nicholas, 1447-1448
Tempera on panel

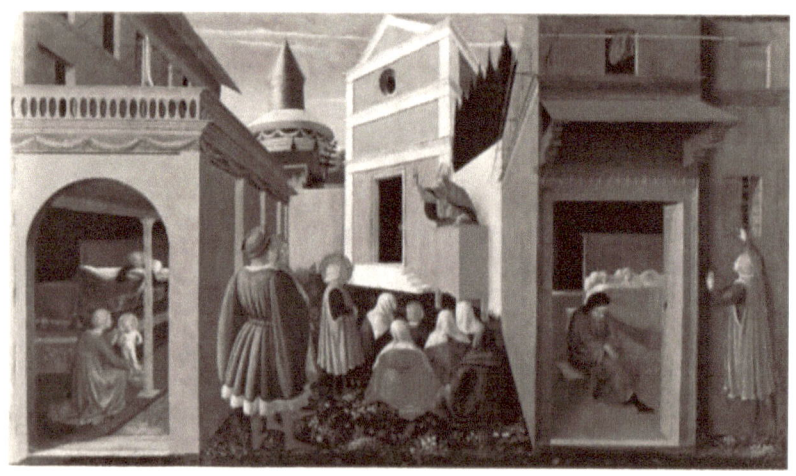

The Story of St. Nicholas, 1447-1448
Tempera on panel

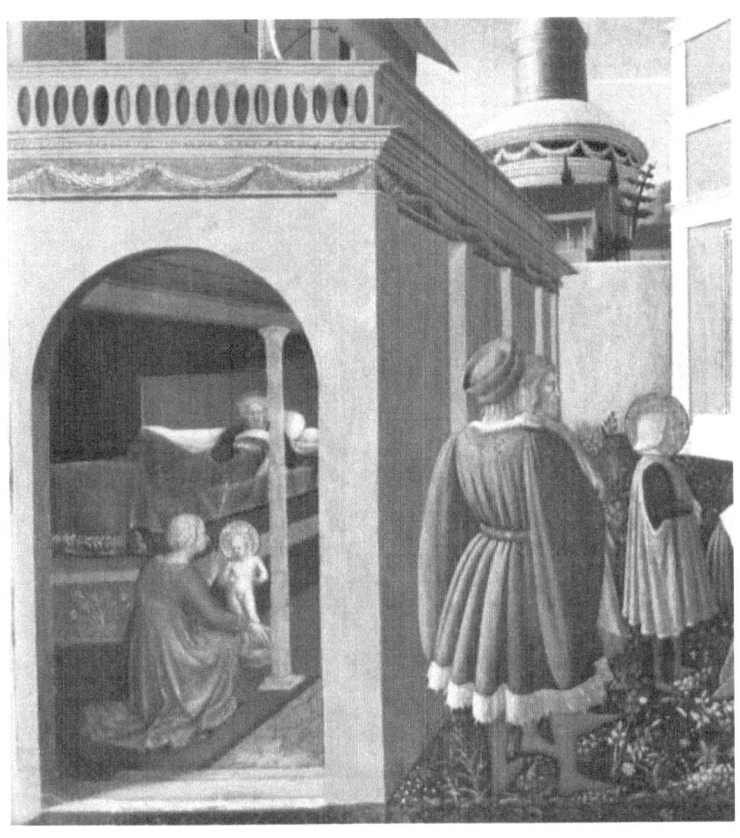

The Story of St. Nicholas, Birth of St. Nicholas, 1447-1448
Tempera on panel

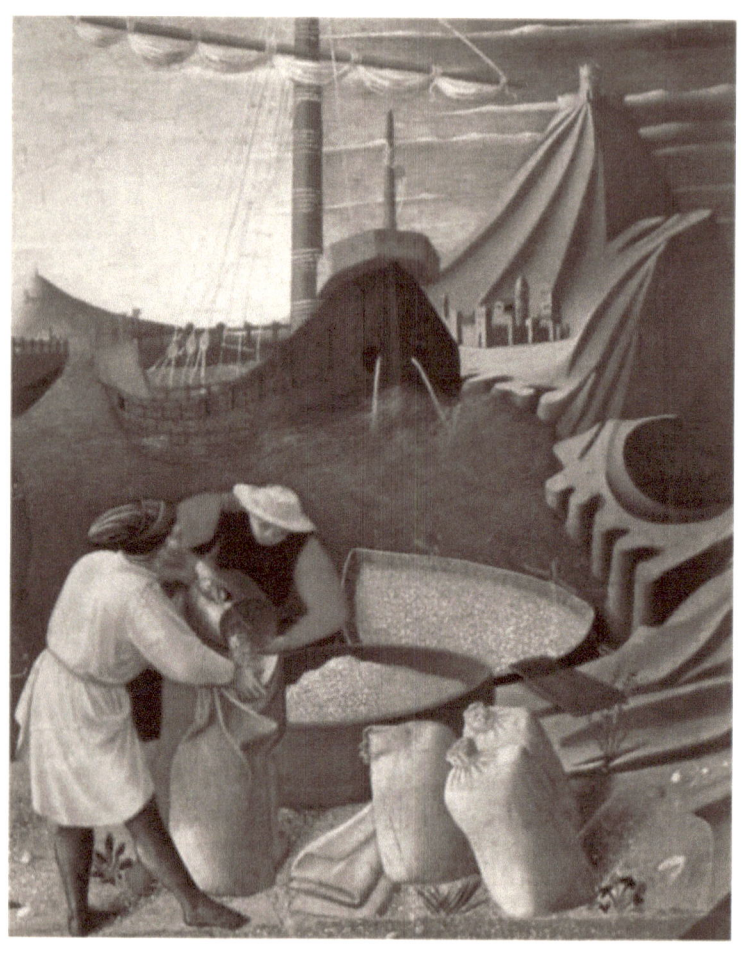

The Story of St. Nicholas, St. Nicholas saves the ship
(detail), 1447-1448
Tempera on panel

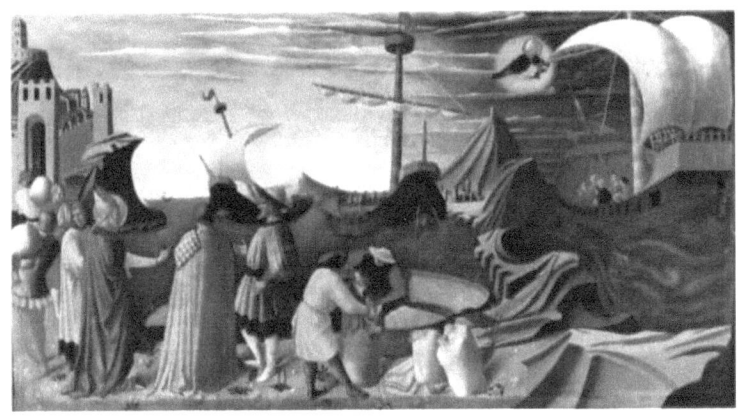

The Story of St. Nicholas: St. Nicholas saves the ship,
1447-1448
Tempera on panel

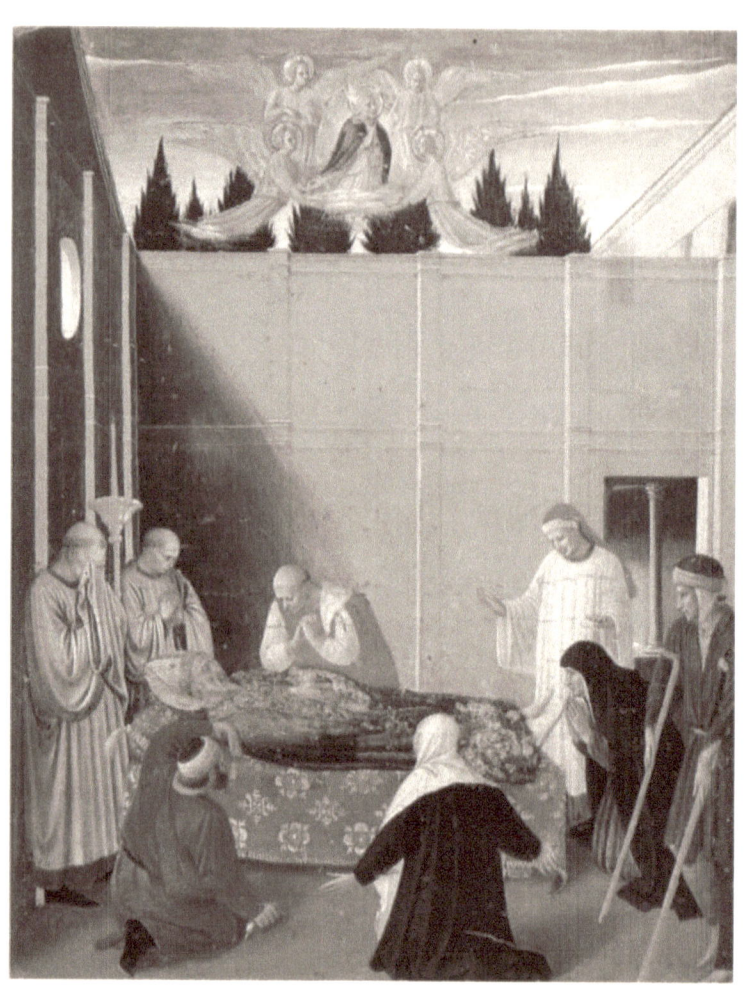

The Story of St. Nicholas: The Death of the Saint, 1447-1448
Tempera on panel

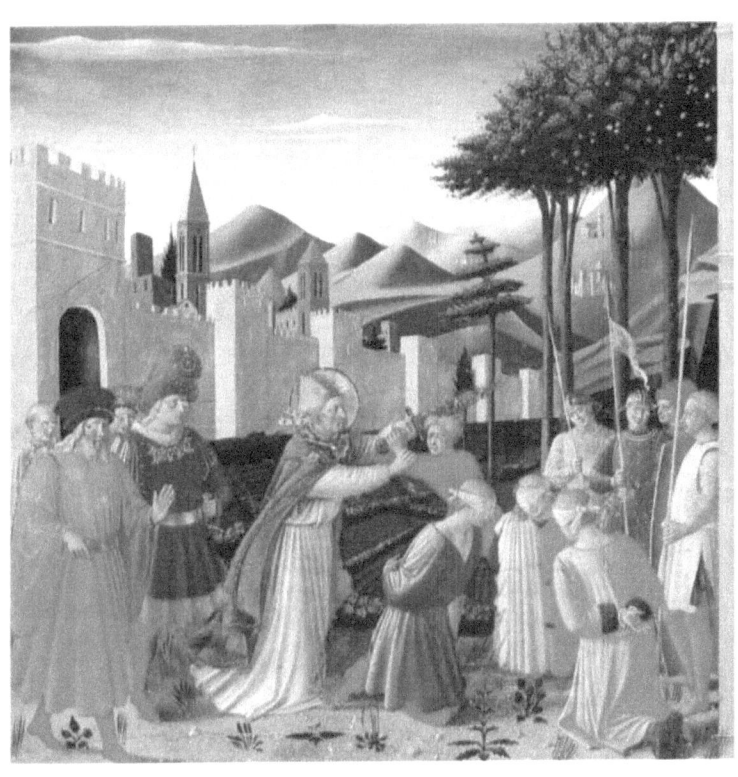

The Story of St. Nicholas: The Liberation of Three Innocents, 1447-1448
Tempera on panel

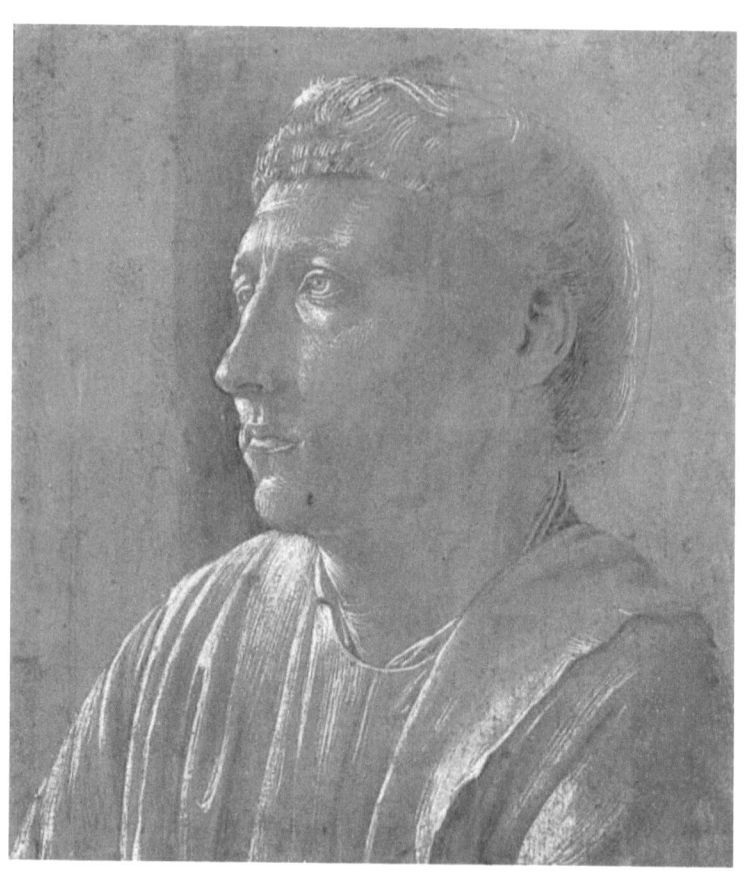

Head of a Cleric, c. 1448
Metalpoint on prepared ochre surface, heightened with white, 189 x 173 mm

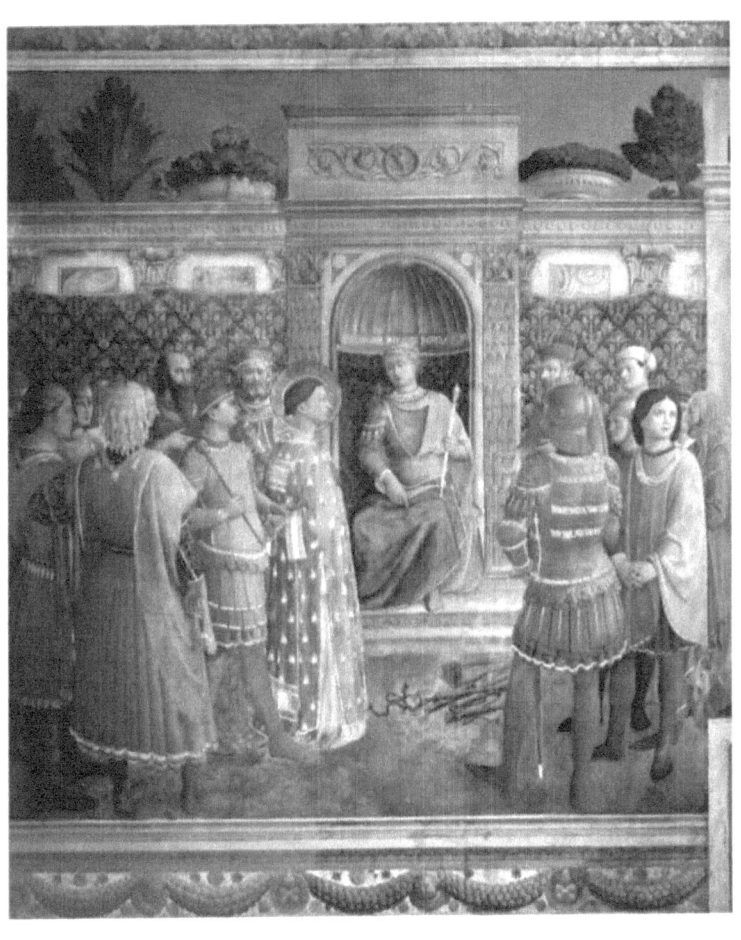

Condemnation of St. Lawrence by the Emperor
Valerian, 1447-1449
Fresco

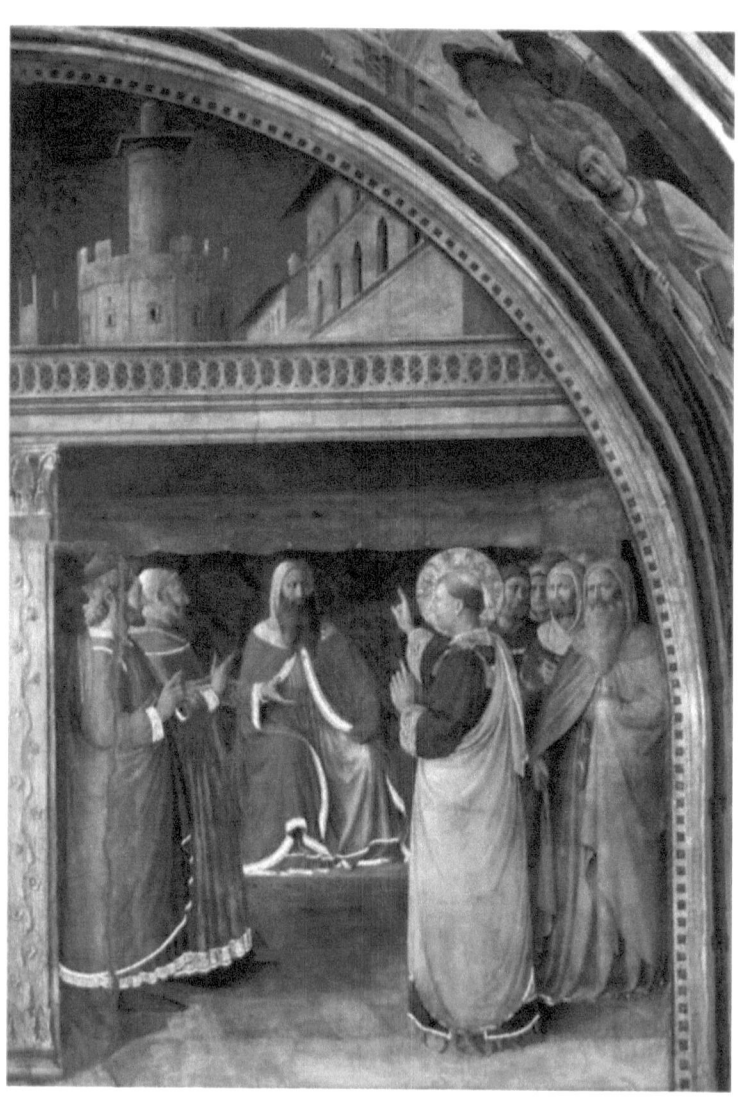

Dispute before Sanhedrin, 1447-1449
Fresco

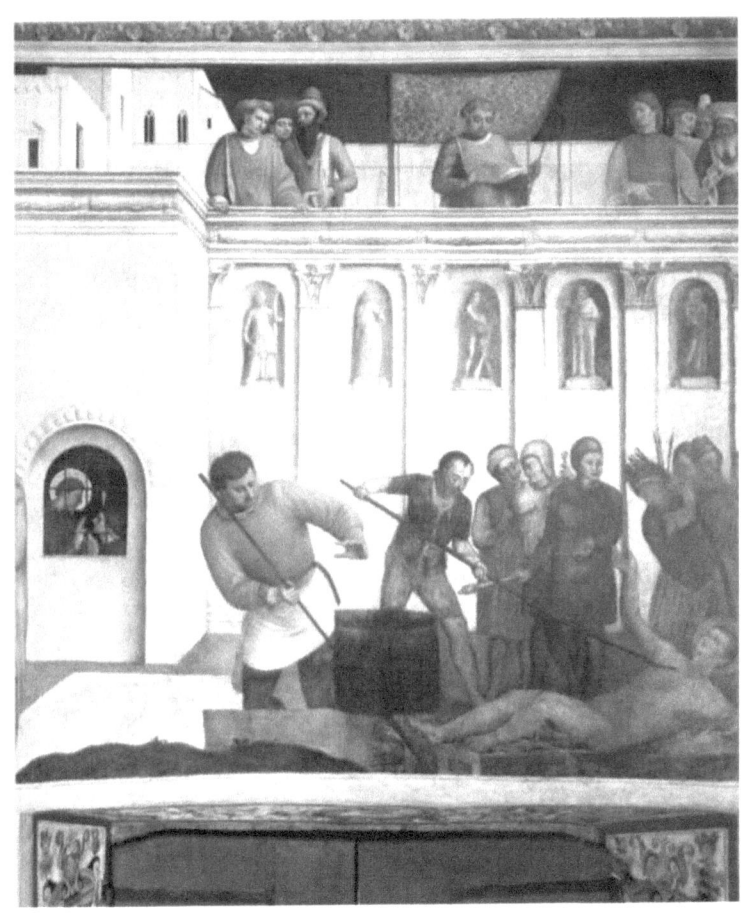

Martyrdom of St. Lawrence, 1447-1449
Fresco

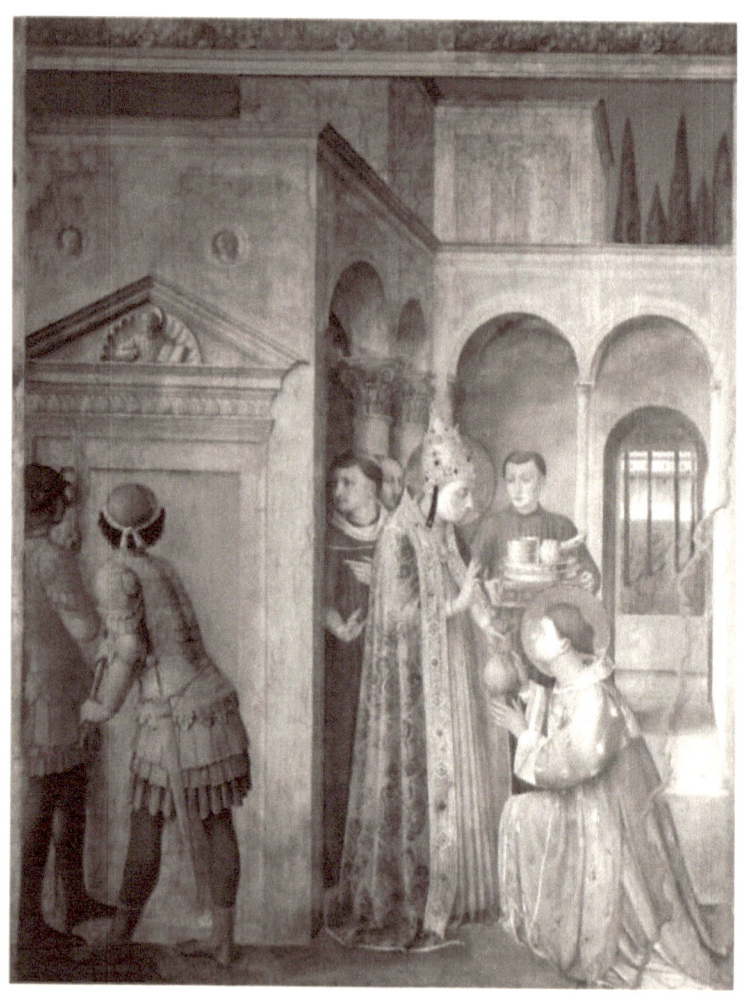

Saint Lawrence Receiving the Treasures of the Church
from Pope Sixtus II, 1447-1449
Fresco

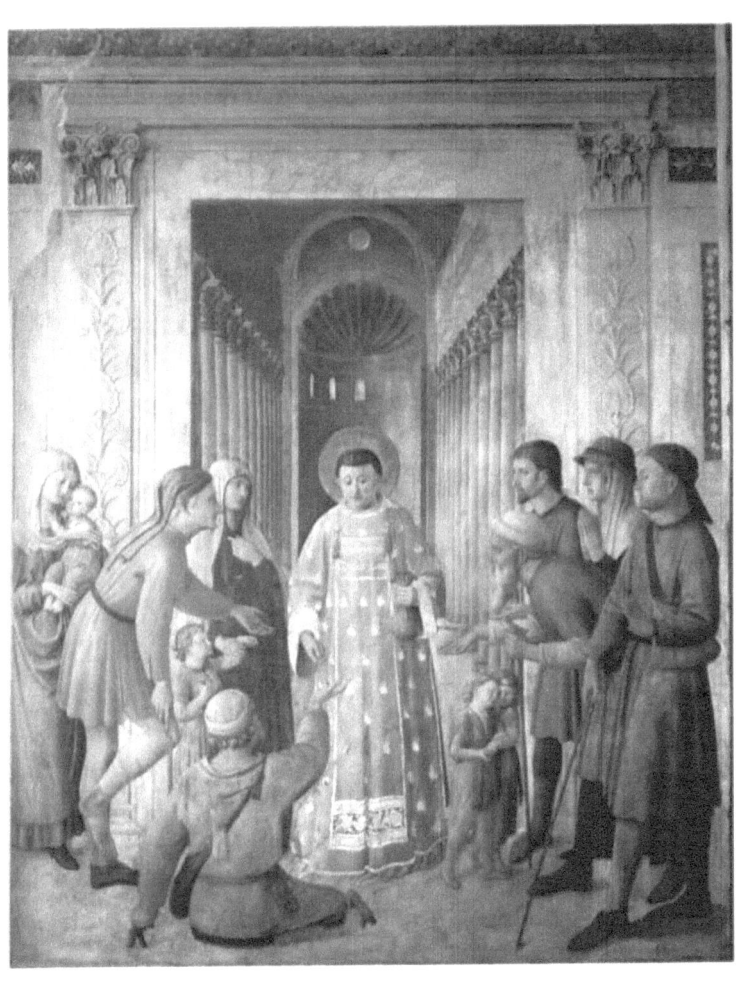

St. Lawrence giving alms, 1449
Fresco

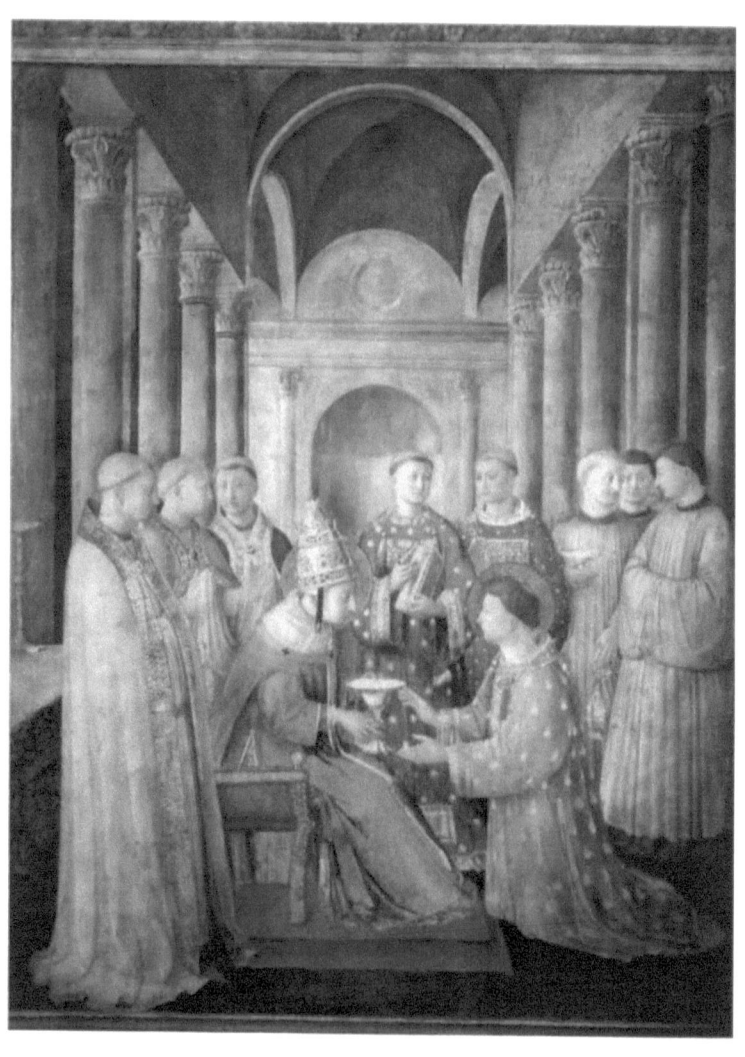

St. Peter Consacrates St. Lawrence as Deacon, 1447-1449
Fresco

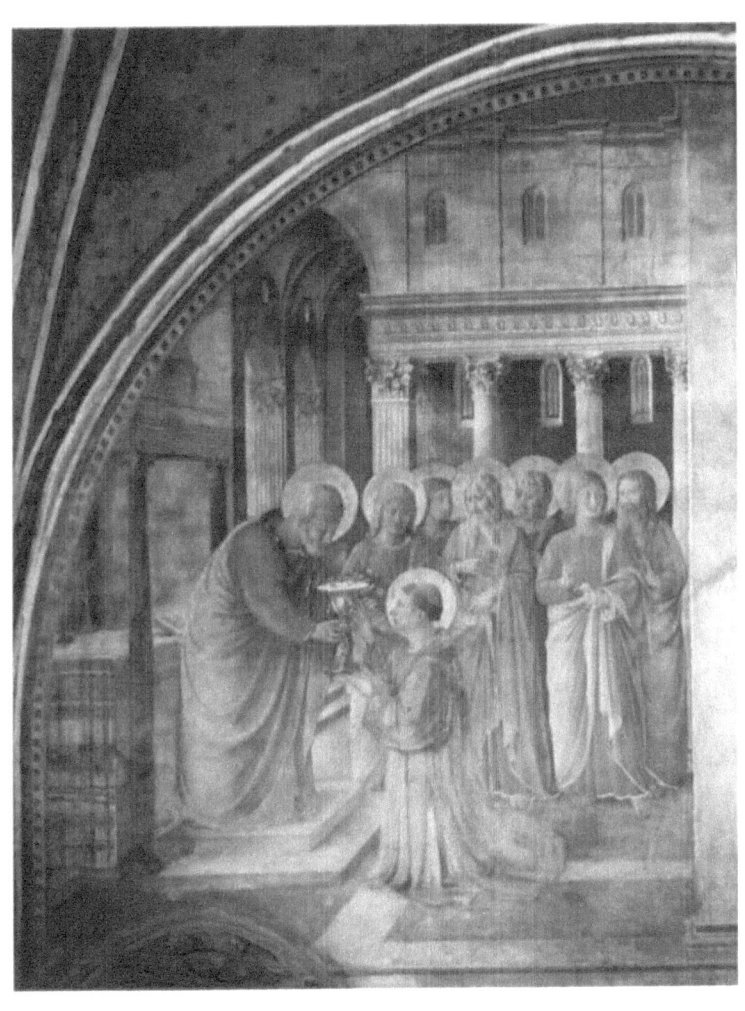

St. Peter Consacrates Stephen as Deacon, 1447-1449
Fresco

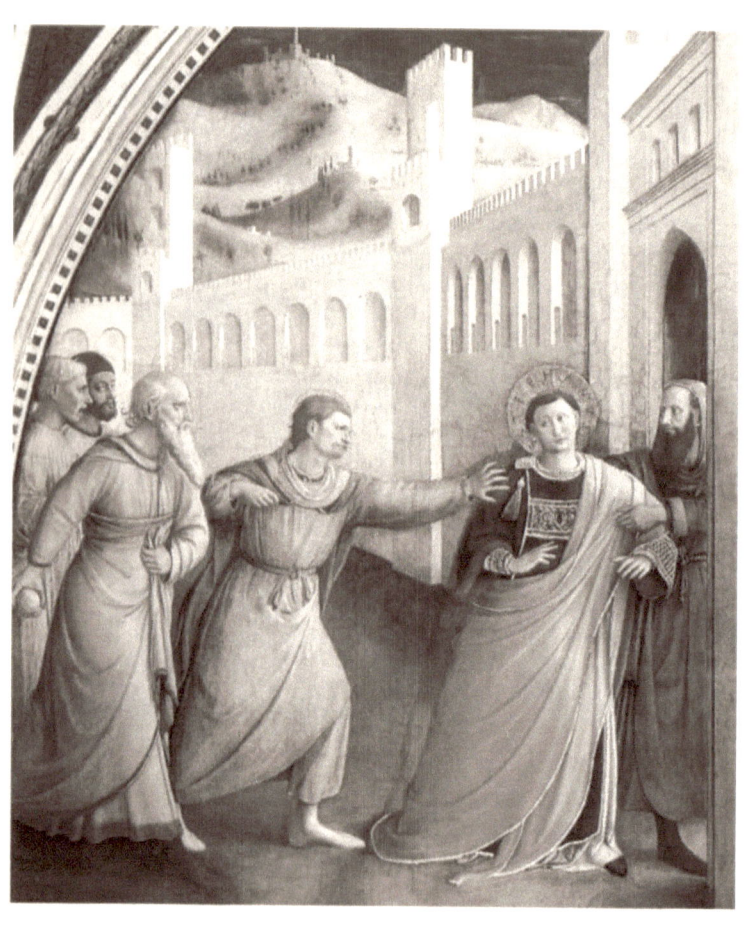

St. Stephen Being Led to his Martyrdom, 1447-1449
Fresco

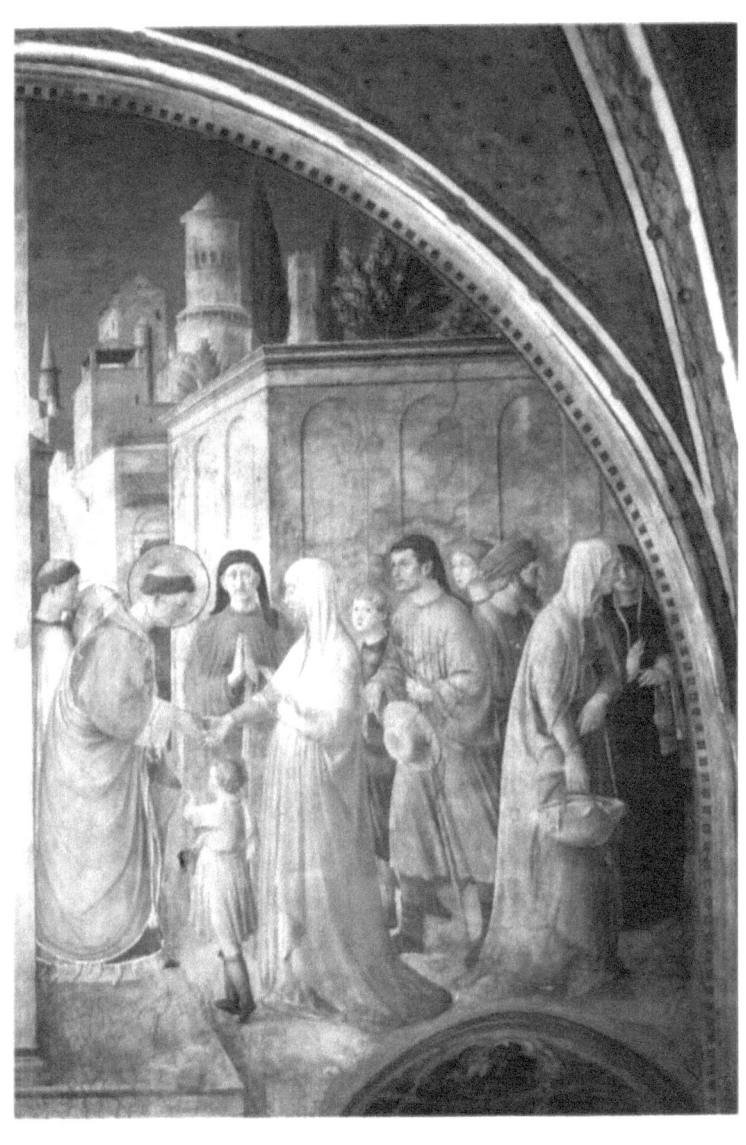

St. Stephen Distributing Alms, 1447-1449
Fresco

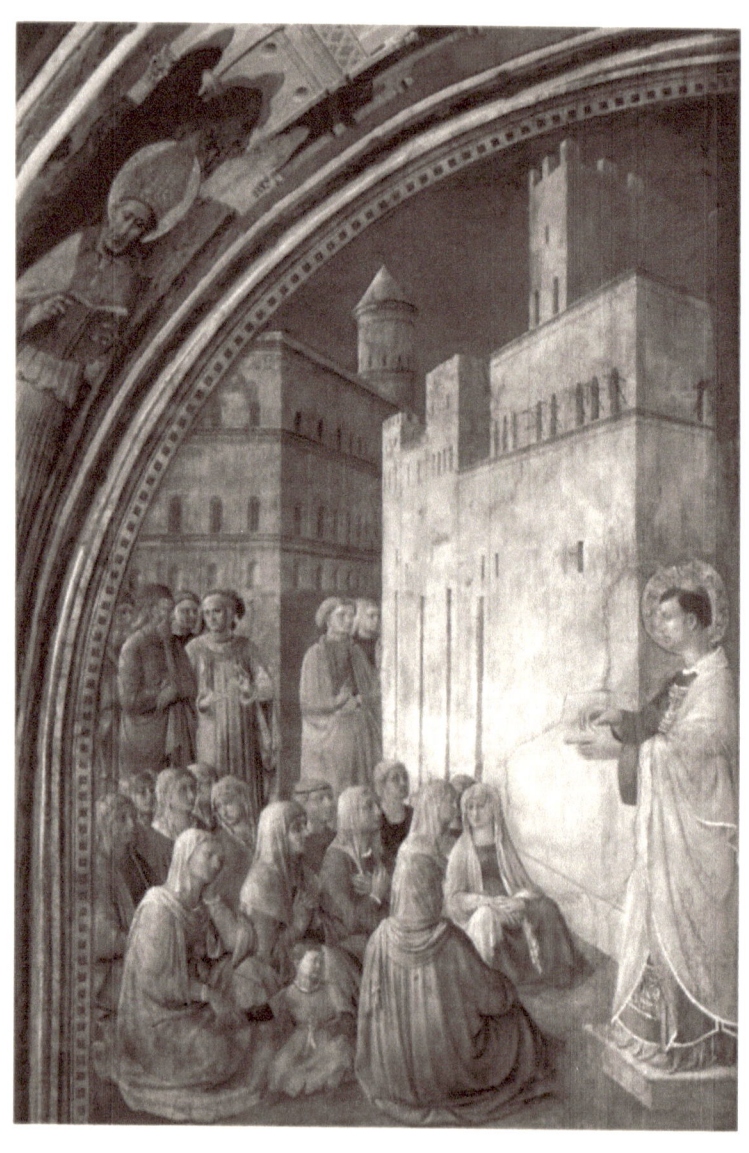

The Sermon of St. Stephen, 1447-1449
Fresco

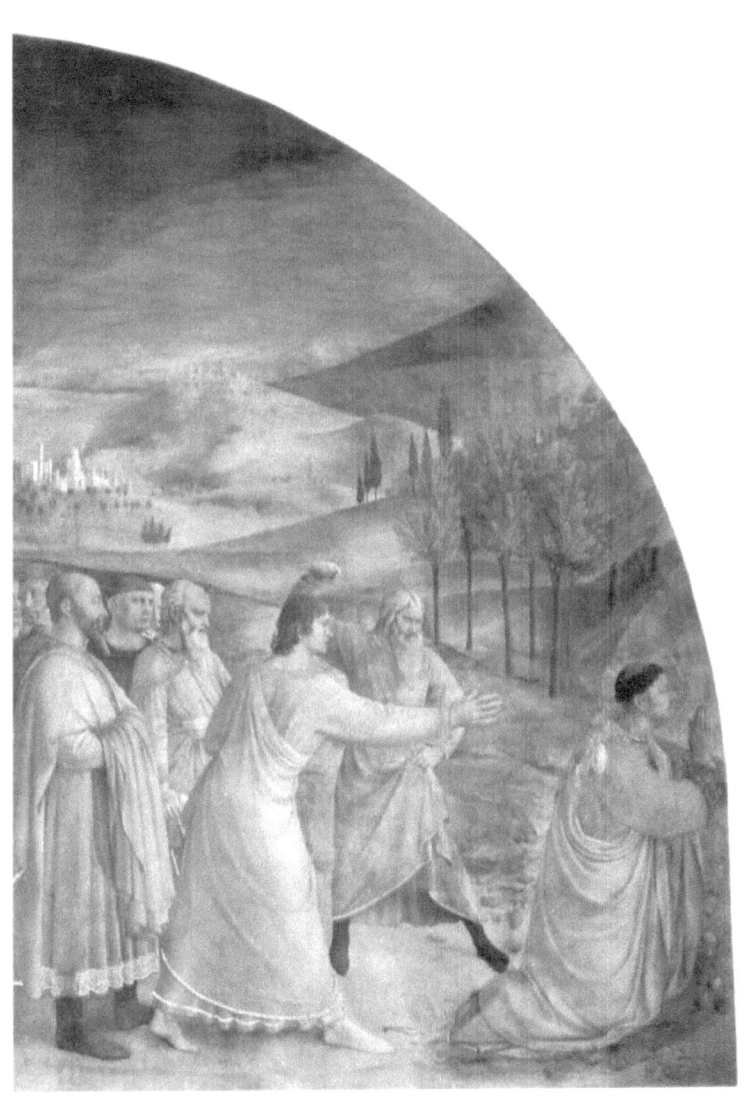

The stoning of Stephen, 1447-1449
Tempera on panel

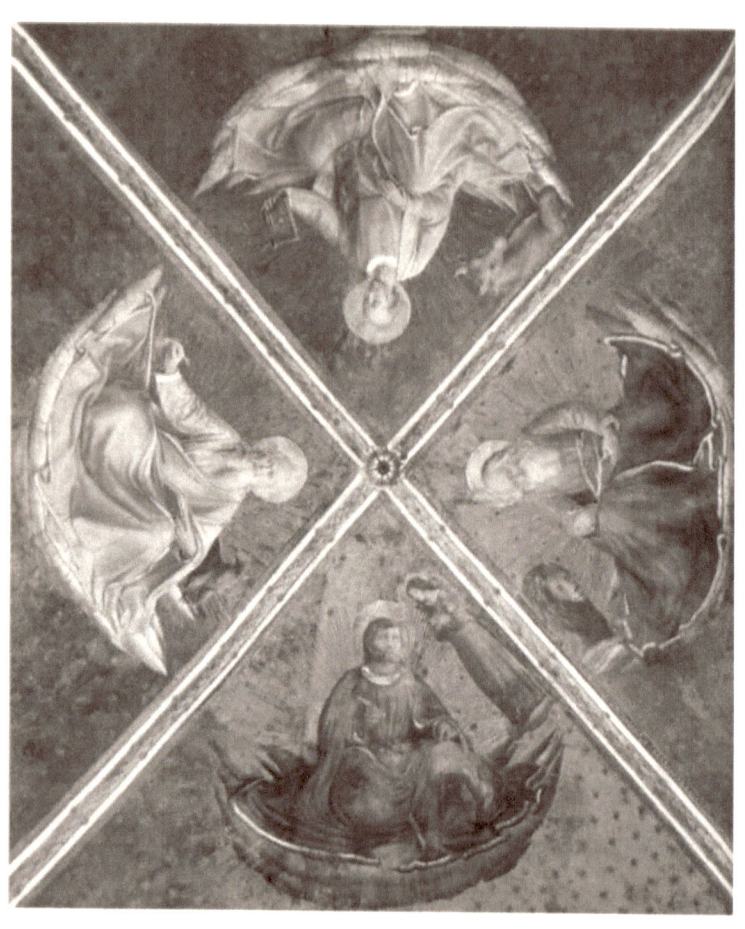

View of the chapel vaulting, 1447-1449
Fresco

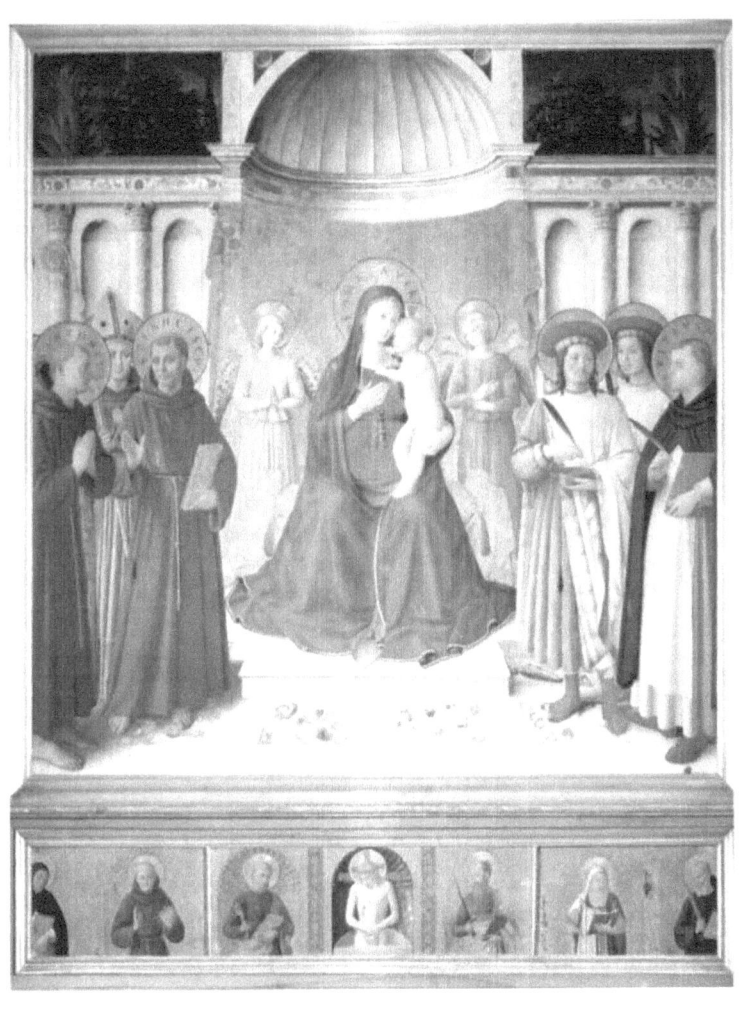

Bosco ai Frati Altarpiece, c.1450
Tempera on panel

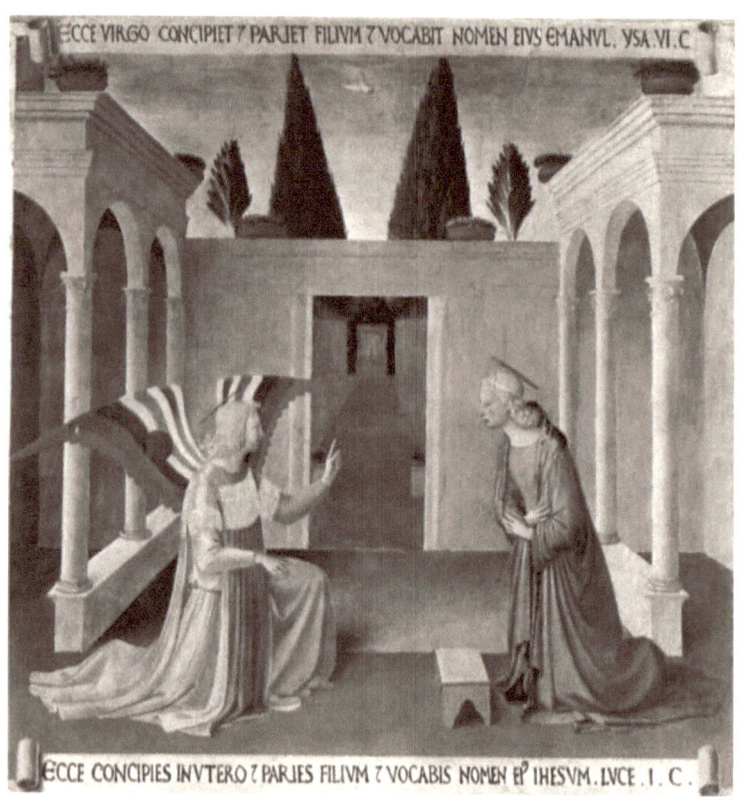

Annunciation, 1451-1452
Tempera on panel

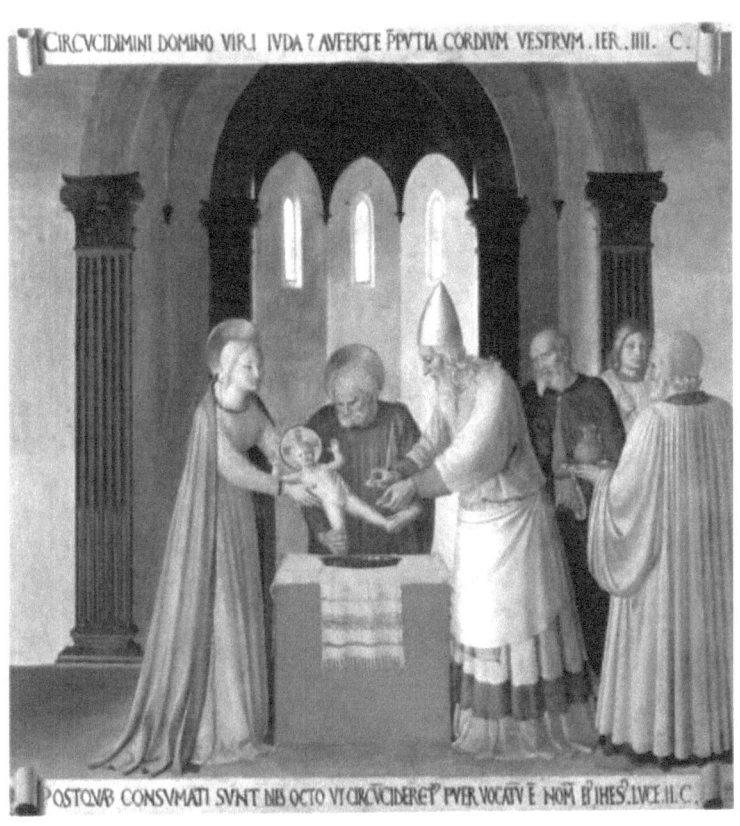

Circumcision, 1451-1452
Tempera on panel

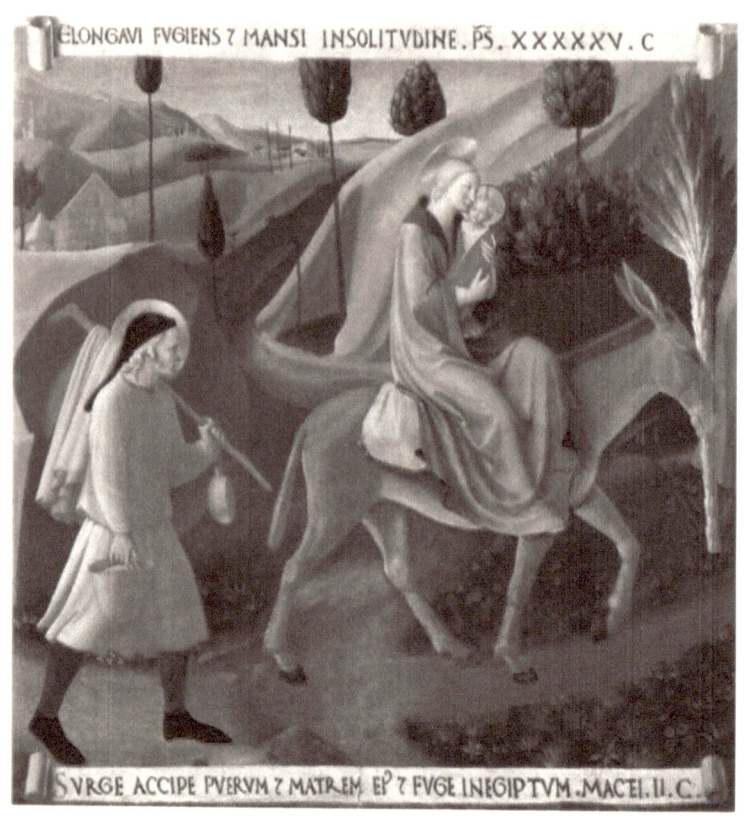

Flight into Egypt, 1451-1452
Tempera on panel

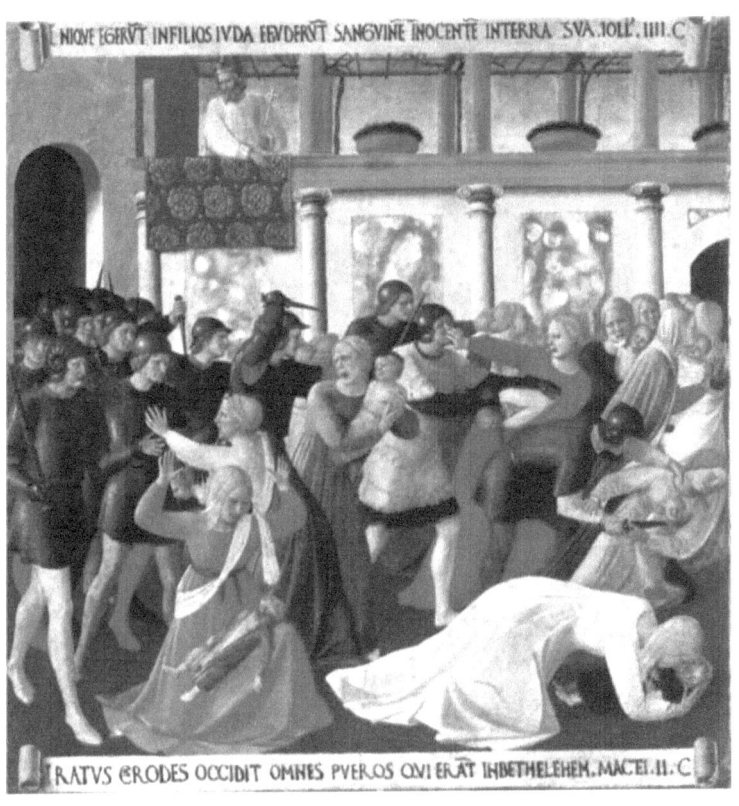

Massacre of the Innocents, 1451-1452
Tempera on panel

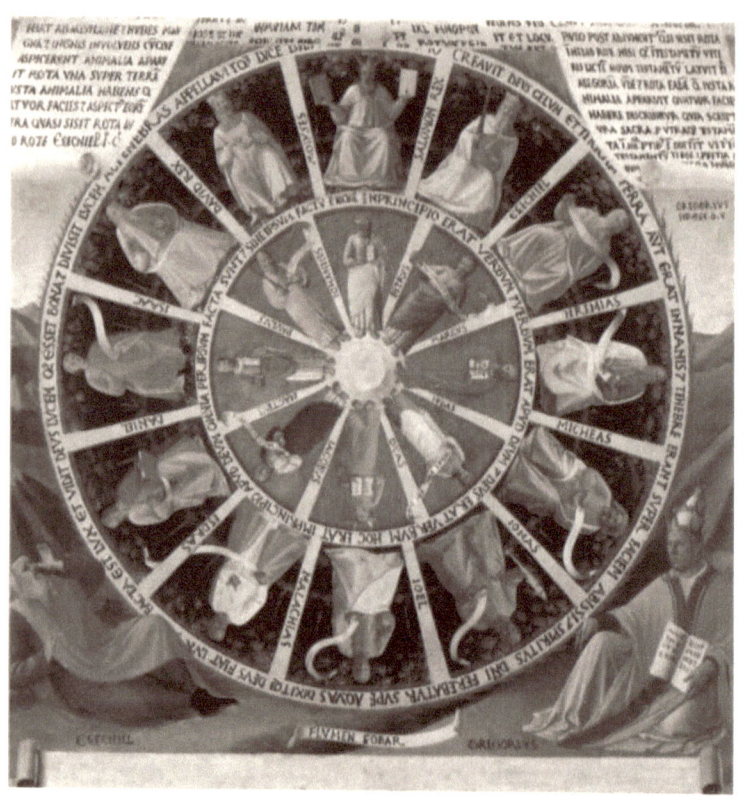

Mystic Wheel (The Vision of Ezekiel), 1451-1452
Tempera on panel

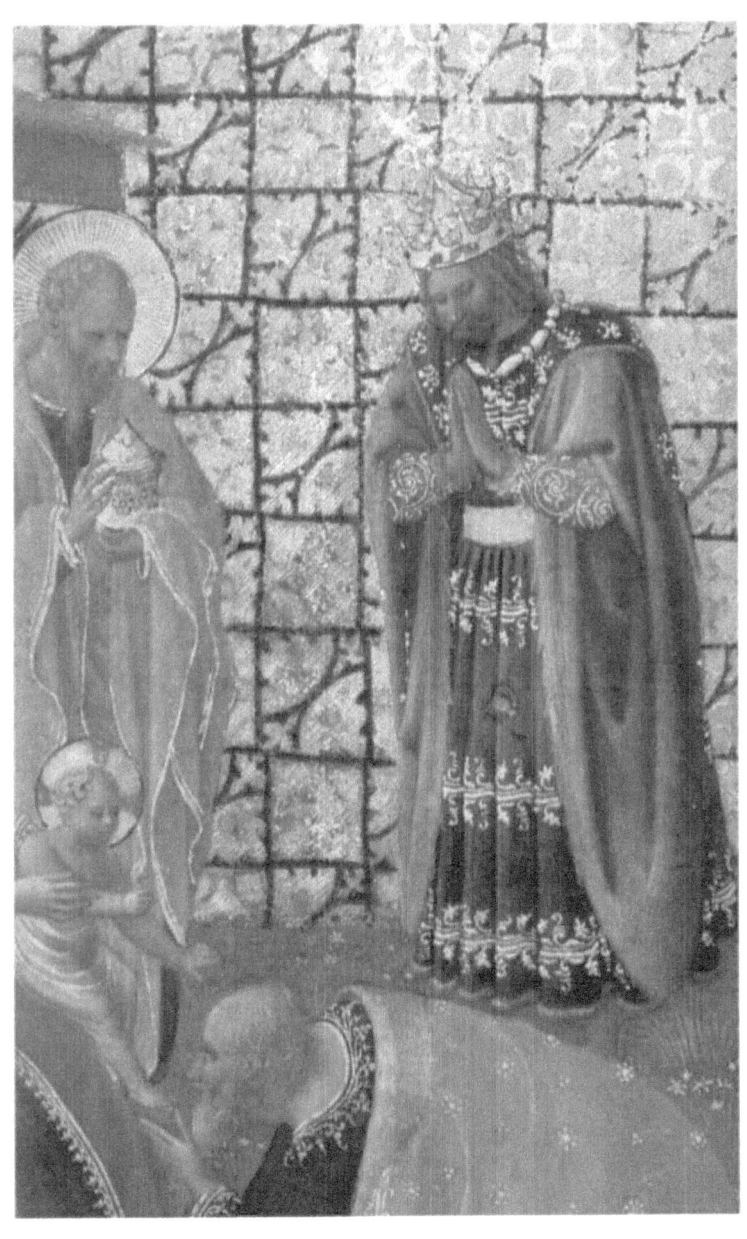

Adoration and Annunciation
Tempera on panel

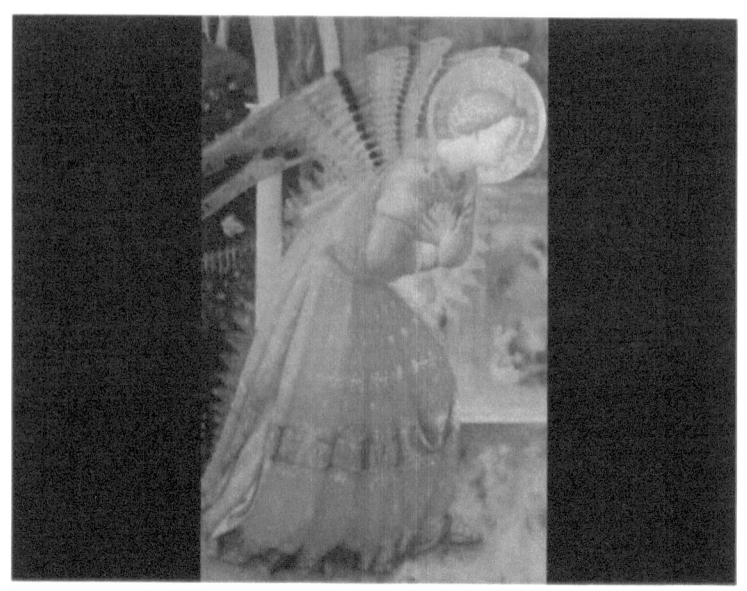

Annunciation (detail)
Tempera on panel

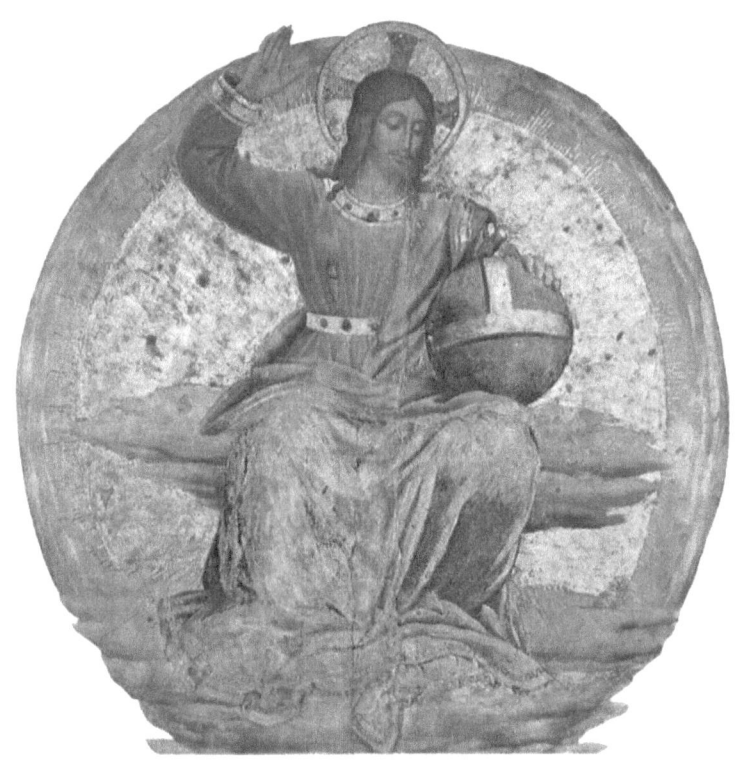

Christ the Judge
Fresco

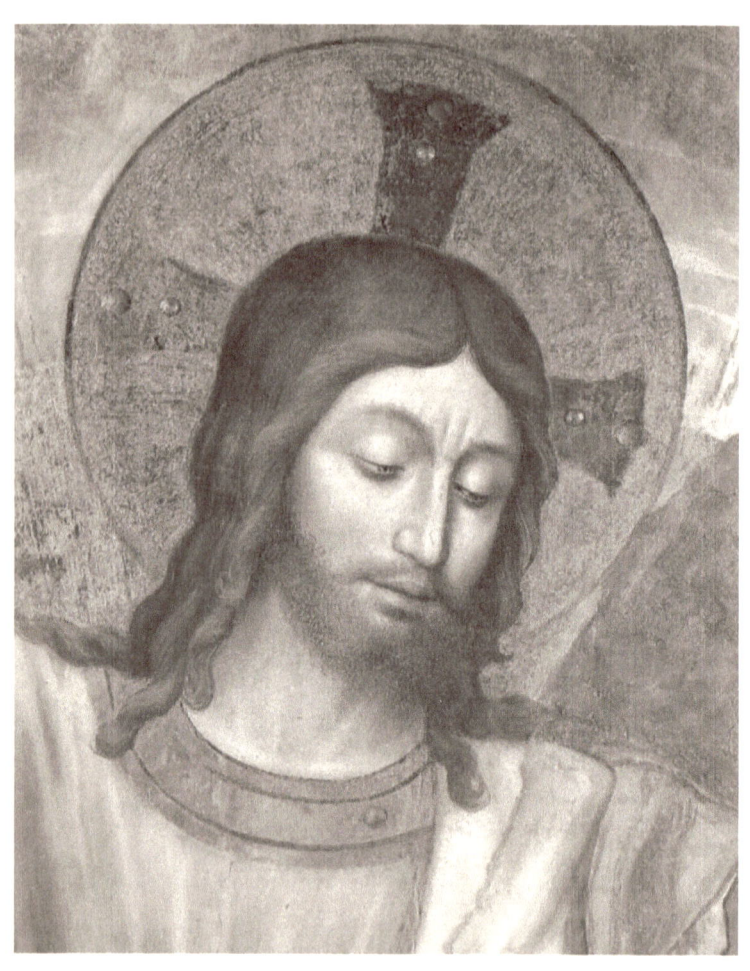

Christ the Judge (detali)
Fresco

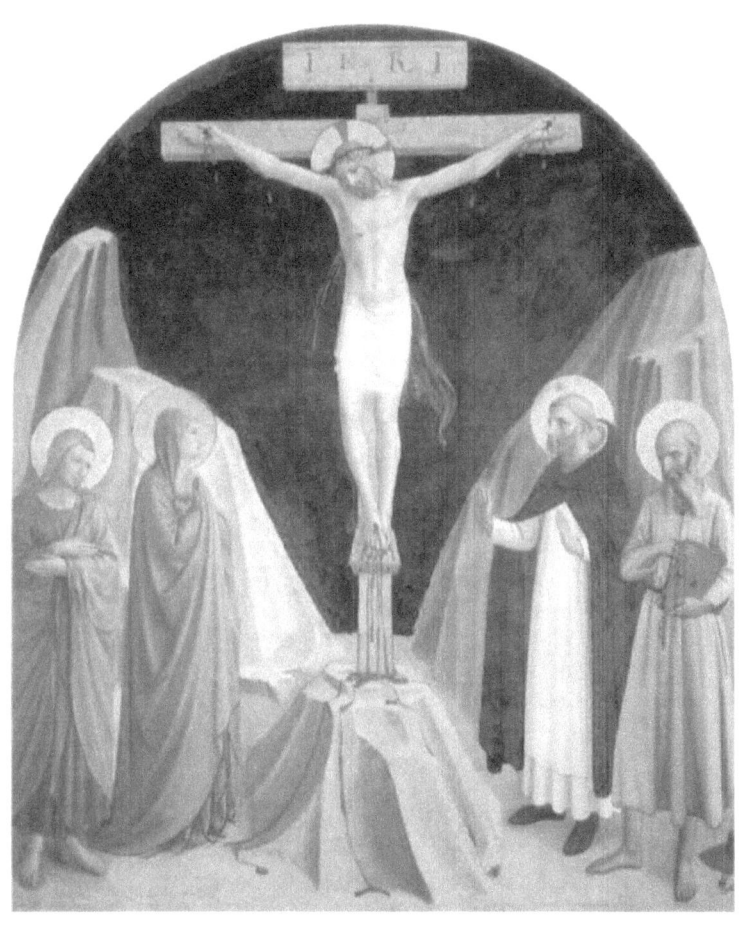

Crucified Christ with Saint John the Evangelist
Tempera on panel

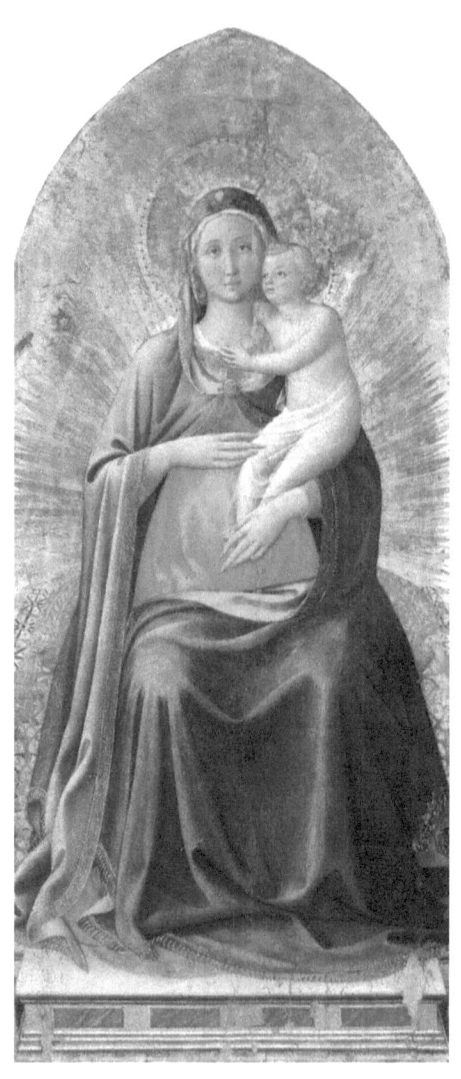

Madonna and Child
Tempera on panel

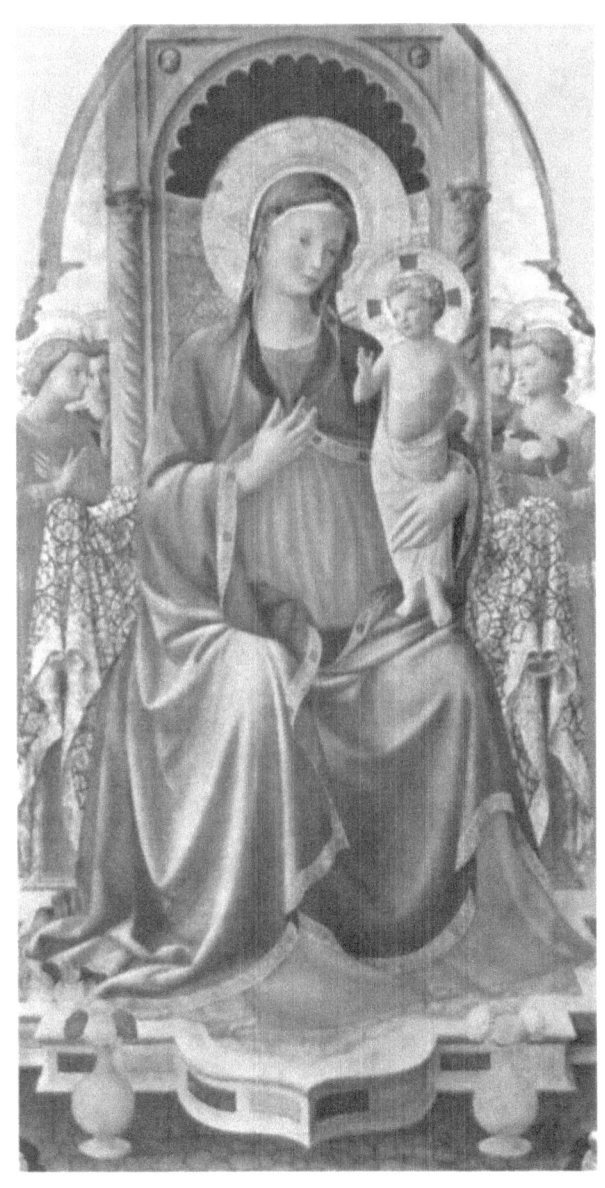

Madonna with the Child and Angels
Tempera on panel

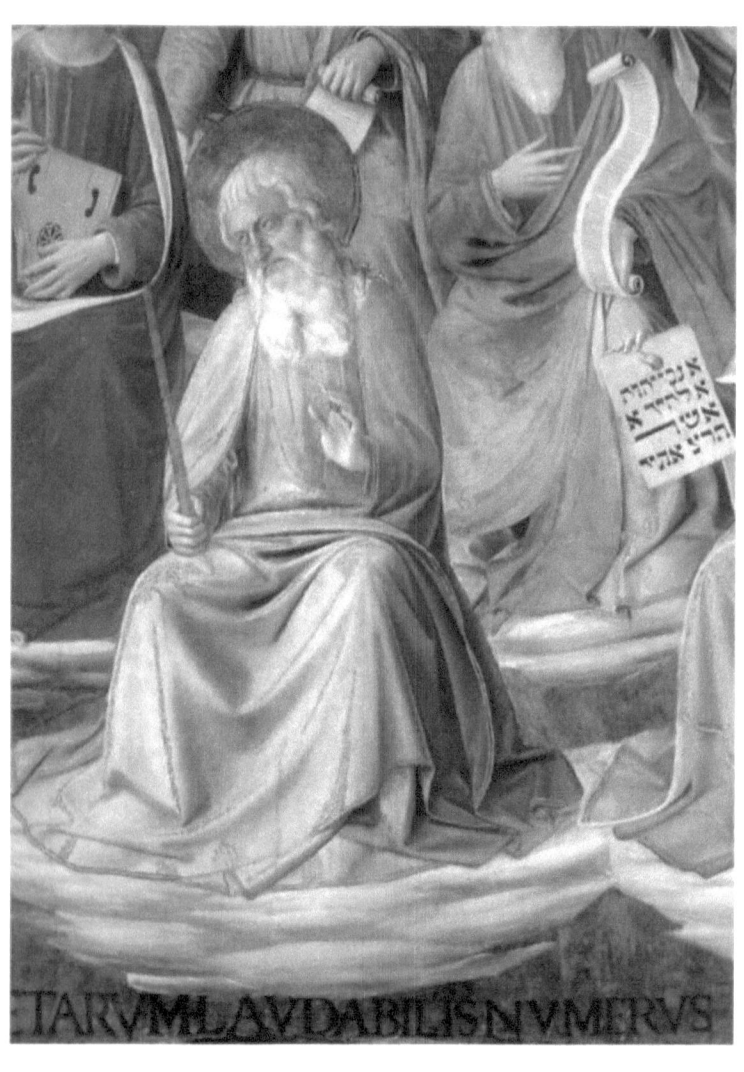

Prophets (detail)
Fresco

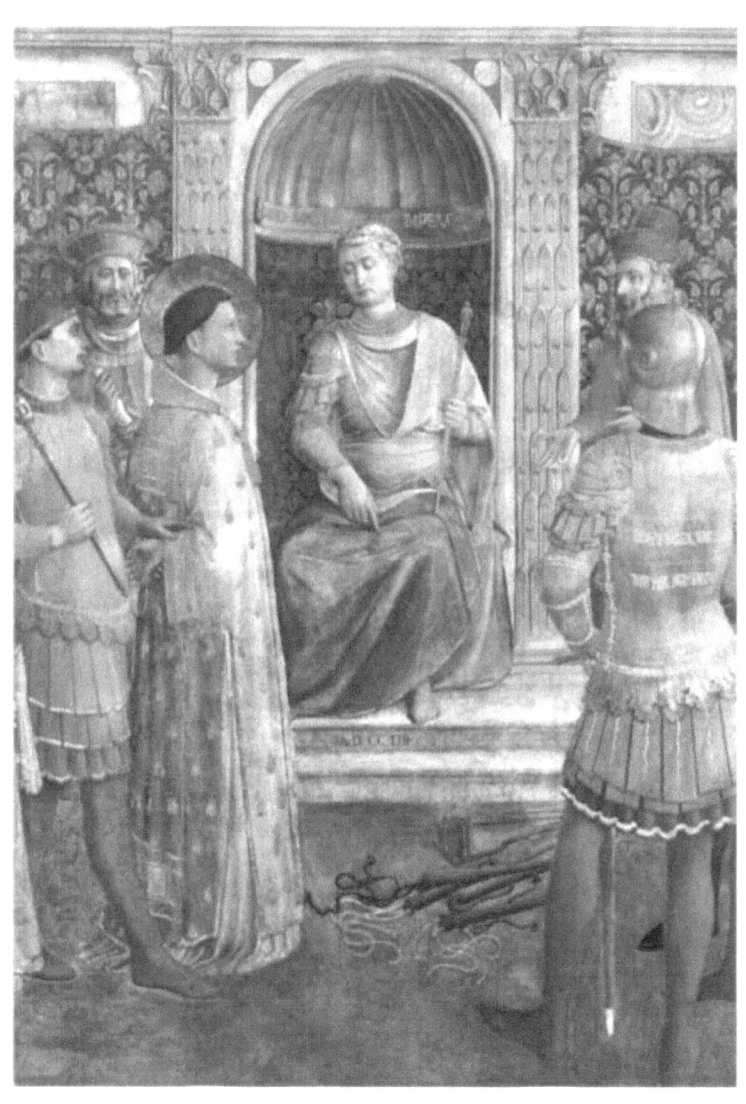

St. Lawrence on Trial
Fresco

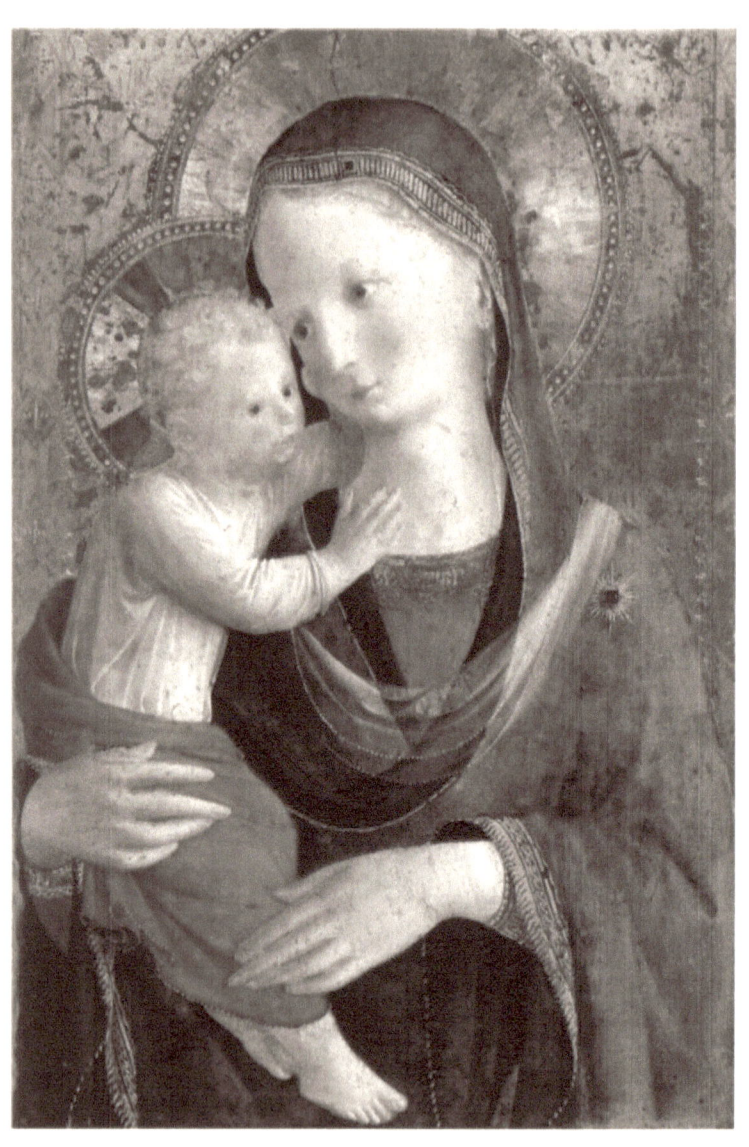

Virgin and Child
Tempera on panel

www.ingramcontent.com/pod-product-compliance
Lightning Source LLC
Chambersburg PA
CBHW030818180526
45163CB00003B/1332